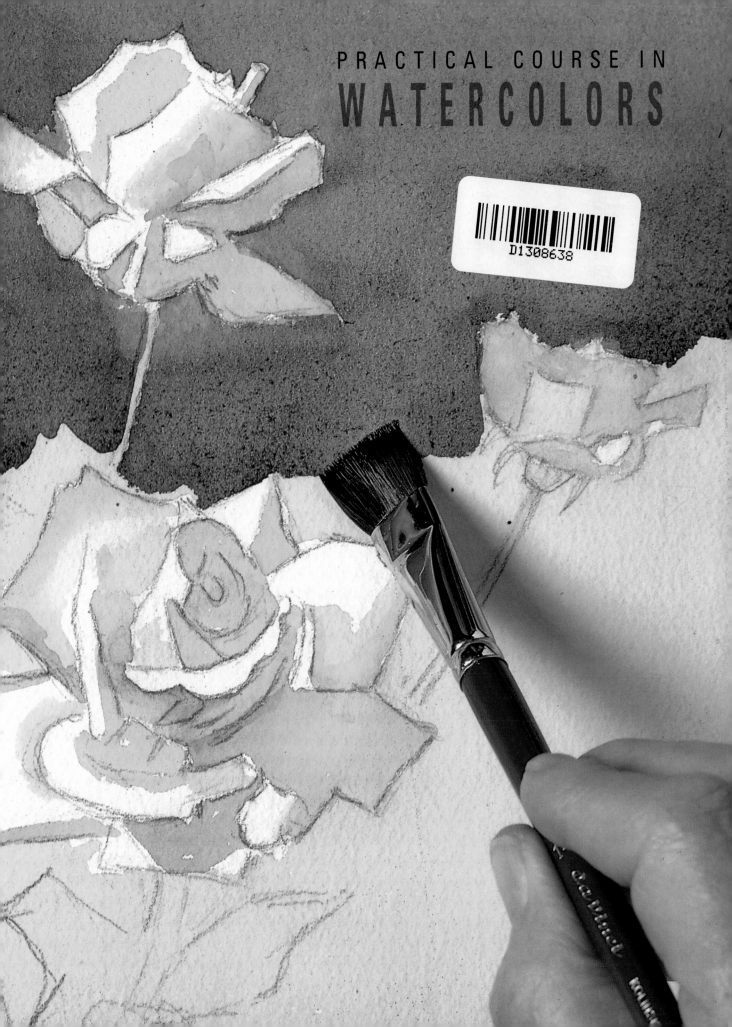

PRACTICAL COURSE IN
WATERCOLORS

D1308638

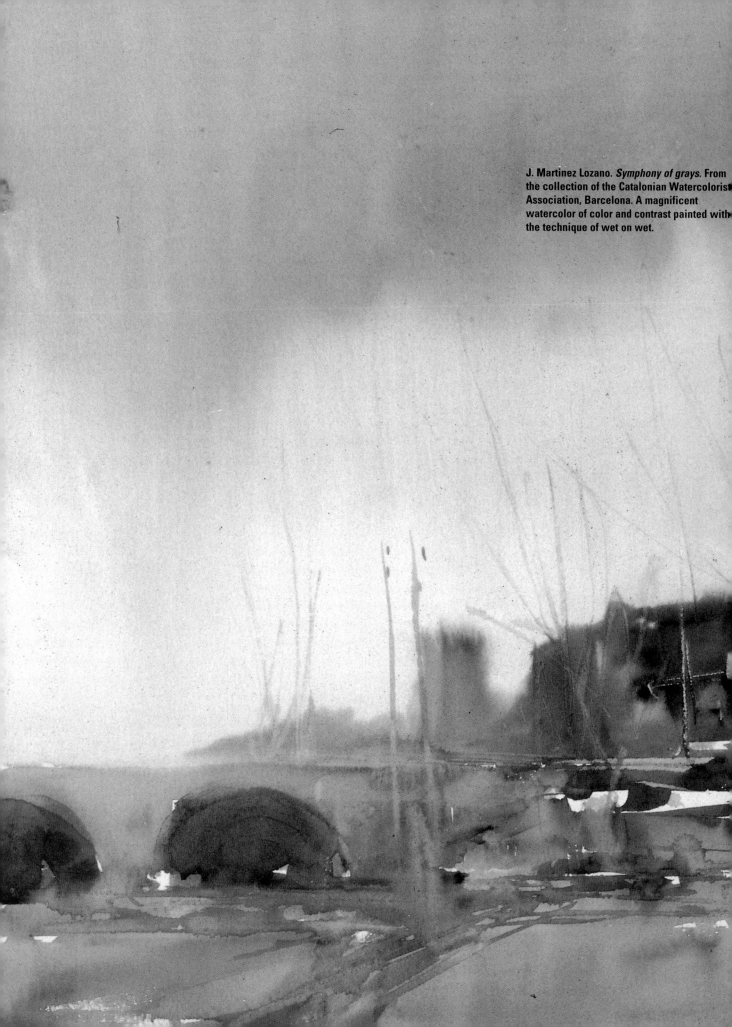

J. Martinez Lozano. *Symphony of grays*. From the collection of the Catalonian Watercolorist Association, Barcelona. A magnificent watercolor of color and contrast painted with the technique of wet on wet.

PRACTICAL COURSE IN
WATERCOLORS
MATERIALS & TECHNIQUES

JOSÉ M. PARRAMÓN

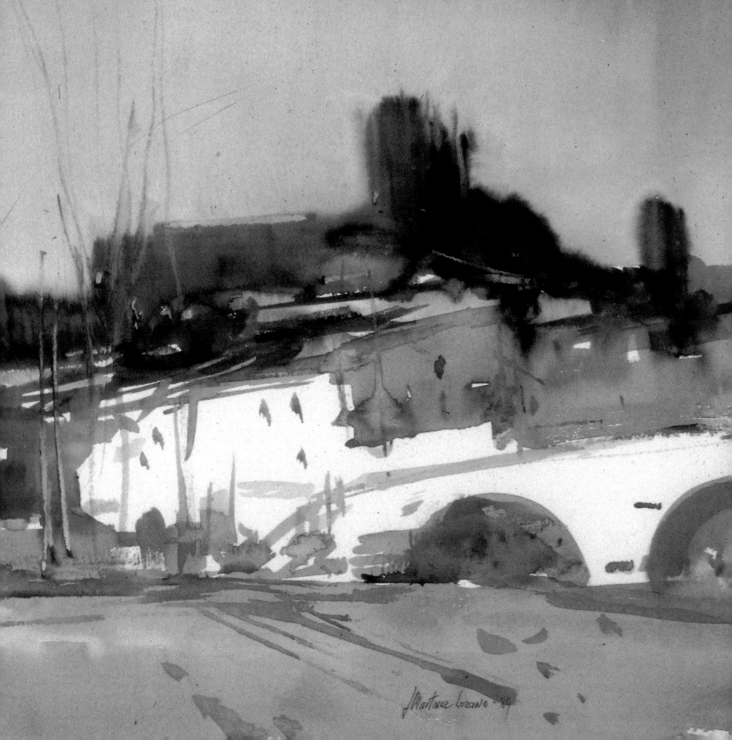

Fig.1. José M Parramon (b. 1919). *Entrance to a farm house* (fragment). The steps, the staircase leading up to the door, the plants and the flowers, but above all the sunlight and the play of the shadows, led me to choose this theme and to paint this watercolor.

General Editor: José M. Parramón Vilasaló
Texts: José M. Parramón and Iván Tubau
Editing, layout and dummy: José M. Parramón
Cover: J. Gasper Romero and José M. Parramón

Photocromes and phototypesetting: Novasis, S.A.L.
Photography: Studio F. Vila Massip

1st Edition: October 1997
© José M. Parramon Villasaló
© Exclusive edition rights: Ediciones Lema S.L.
Edited and distributed by Ediciones Lema S.L.
Gran Via de les Corts Catalanes, 8-10, 1st 5th A
08902 L'Hospitalet de Llobregat (Barcelona)

ISBN 84-95323–09-5

Printed in Spain

The total or partial reproduction of
any part of this book, through printing,
photocopying, microfilm or any other
system is strictly prohibited without
the written permission of the editor.

Table of Contents

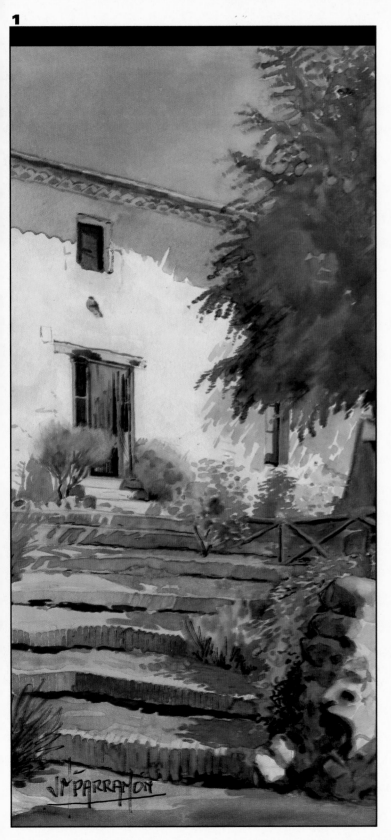

1

Introduction to Practical Course in Watercolors

2

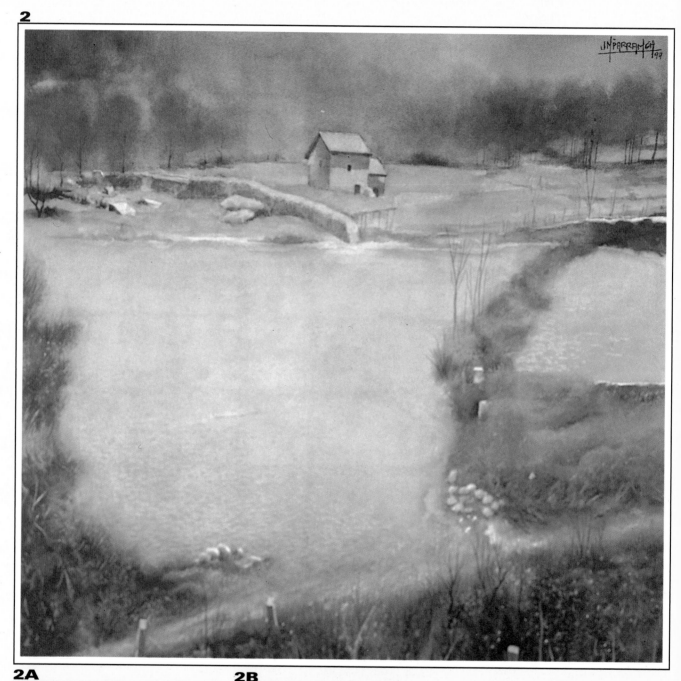

2A

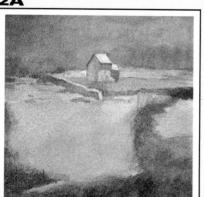

2B

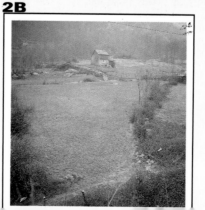

Figs. 2, 2A and 2B. Jose M. Parramon (b. 1919) *Shelter in the High Mountains.* Artist's collection. To paint this water-colour I first made a sketch (20 x 20 cm), painting from life in the mountains of the French Pyrenees (fig. 2A). In the same place I took a photograph (fig. 2B) and later, in the studio, with the help of both things, I painted the final picture measuring 50 x 55 cm.

Until the middle of the XVI century, at the time of **Leonardo** and **Michael Angelo**, artists were regarded as simple artisans. Painters belonged to the guild of knifemakers and harnessmakers. Until then **Leonardo da Vinci** and **Michael Angelo Buonarroti** fought for, and achieved, painting not to be simply considered a manual activity, a job, but rather a spiritual expression, like poetry. *"One paints with one's head, not one's hand"* as **Michael Angelo** said.

This phrase is particularly applicable to watercolor painting: a medium whose existence depends, among other things, on calculation and studying the subject, and its white or light areas, i.e., previously reserving these areas. This medium also depends on imagining beforehand the clear progressive development of the picture, *always painting from less to more*; and calculating how to achieve the mixes and shades by superimposing layers of color; and, finally, it depends on foreseeing and calculating each step without there being possibility of going back to rectify mistakes, or resort to *pentimento* (repentance) which is possible and so frequently done with other mediums such as oil, fresco, acrylics, gouache....

So yes: *"Watercolor is painted with one's head"*. In this collection, *Practical Course in Watercolors,* we have brought together all the lessons so that you can, and will, know how to paint with your head, you will know how to think, foresee, calculate and develop, fully understanding the causes and effects, and with practical and theoretical knowledge of *all the techniques of watercolor painting*, from line drawing, with no shading, calculating dimensions and proportions, to predicting and reserving, or creating white areas; from using a sponge to draw and paint textures, to putting into practise *'tachismo'*:

applying it to a background, a wall, or a cloudy sky.

So, what about "the hand", the manual skill, the knowledge of a professional? This will come gradually, through more than 100 practical exercises which you will do during this whole course. At first with regular backgrounds, then with different tones and with wet and dry gradations. Painting backgrounds and basic shapes, skies, houses, landscapes. Later painting washes, of just one color, learning how to control the paintbrush and how to draw with the brush and the wash, without the complication of color; following this by practising with two colors, to learn how to mix colors and shades. Next we will practise watercolor painting with three colors, yellow, carmine and Prussian blue, with a series of exercises mixing these three colors to obtain an infinite range of colors, learning and putting to the test, that with just these three colors it is possible to paint all the colors in nature. This series of disciplines and exercises will allow you in the end to learn how to mix and paint with all colors. Continuously practising and learning progressively, step by step. Going from the unknown to the known, from first steps, to the most creative of watercolors.

But all this will only be possible *if you work*. It is essential that you do the series of exercises and the practice which you will find on the pages of this course. And the idea that you can't do it is no excuse, that it doesn't come out right, no matter how much you practise, or how hard you try. *"Everything in human life, can be learned and perfected through practice"* wrote the Greek philosopher **Diogenes**, thousands of years ago. **Van Gogh** confirmed this idea, saying: *"You have to practice to progress. As practice makes perfect, it is impossible not to progress"*. How-

3

Fig. 6. José M. Parramón, author of the collection *Practical Course in Watercolors*, also author and editor of over forty books on the instruction of drawing and painting wich have been translated and published in over sixteen countries including Germany, England, France, Italy, the United States, Russia and Japan.

ever, it is natural and logical that at first you will have difficulties, that things won't come out right, and you won't be satisfied. Well, this also happens to the most professional of artists! **María Corral**, the ex-director of the Reina Sofía Museum, said in a recent statement: *"An artist, by definition, is never satisfied. If someone is satisfied, they are not an artist. The main condition for creativity is questioning, insecurity and anxiousness"*. Having said this, let's begin. When you get to page 46 of this book, start to draw and paint and don't stop... secure in the knowledge that practice makes perfect and it is impossible not to progress.

José M. Parramón

4

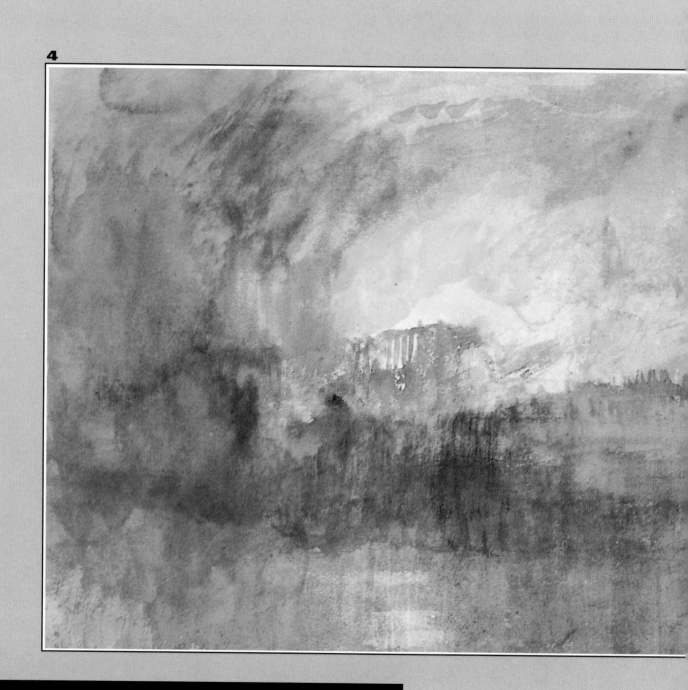

Joseph Mallord Turner (1775- 1851). *Parliament Burning*.
The British Museum, London. Turner painted nine watercolors and several oils of this subject, in his studio, starting
from pencil sketches taken from different viewpoints, he
achieved this famous watercolor, a wonder of realism,
technique and synthesis. He uses a few shapes and just a
few colors to their absolute limit.

A BRIEF HISTORY OF WATERCOLOR PAINTING

It is said that it is very important to know history, so that one doesn't repeat one's errors. However, when talking about the history of a technique, it is even more important, in order to take advantage of what others have discovered. In this *Practical Course in Watercolors*, the history will be brief, to allow more space for the practical part. However, this brevity will be expanded and compensated for by the texts and footnotes which you will be reading and seeing throughout the five volumes of which this course is composed. In this way, the history will be brief, but in the end not lacking any important detail, or at least any detail which could be important for you, as you want to be a painter, not a historian.

Dürer, the First Watercolorist

Albrecht Dürer (1471-1528) was born in Nuremberg. His father was a goldsmith. When **Albrecht** was twelve years old, he left school and entered his father's workshop as an apprentice. However he soon developed a liking for visiting the workshop of his neighbour, **Michael Wolgemut**, a famous painter and creator of box wood engravings to illustrate books. **Wolgemut** suspected that young **Albrecht**, who already drew, would end up being a painter: he said to **Albrecht**'s father, *"This boy of yours will not work gold like you do, he won't be a goldsmith, he'll be a painter"*. But **Dürer senior** wanted his son to be a goldsmith like himself, and wanting expand his business, he even opened a new workshop near the government buildings in Nuremberg.

Then the unexpected happened, **Young Dürer**, thirteen years old, drew the celebrated self-portrait which is now in the Albertina Museum in Vienna. **Dürer senior** went to visit **Wolgemut**, and said *"You were right, my son will not be a goldsmith, look"* and he showed him the self portrait (fig. 5).

During the three years that he studied with his teacher **Wolgemut**, **Dürer** perfected his extraordinary talents as draughtsman and painter and learnt the secrets of xylography, the art of wood engraving which would, in time, make **Dürer** the most famous engraver in Europe. Five years later, in 1494, after getting married, **Dürer** travelled to Venice. One year later, on his way back to Nuremberg, he passed through the Italian Alps and painted the first western landscapes in watercolor.

When he returned to Italy the experience he had had with these landscapes enabled him to paint this magnificent view of Nuremberg, in which **Dürer** demonstrated his knowledge and his ability to portray the atmosphere in the distant grounds (fig. 6).

Albrecht Dürer painted in total thirty landscapes in watercolor; he also painted animals, plants, trees and studies like this *Wing of a blue bird* (fig. 7), which is quite extraordinarily well-drawn and colored.

Despite the artistic quality of his watercolors, Dürer considered them to be simple studies which *"I cannot honourably sell for money"*.

5

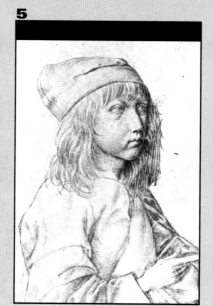

Fig. 5. Albrecht Dürer (1471-1528). *Self-portrait*, drawing. Albertina, Vienna. In the upper right hand margin of the picture, Dürer wrote: "I drew this self portrait looking at myself in a mirror, in 1484, when I was still a child. Albrecht Dürer".

Fig. 6. Albrecht Dürer. *View of Nuremberg*. The watercolor disappeared in 1945, before that it had been in Breme, Kunsthalle. This magnificent watercolor was painted by Dürer when he was 24 years old. It was considered to be a miniature because of its small size, just 15 x 34 cm. The admirable contrast and the atmosphere captured by Dürer have to be noted.

Fig. 7. Albrecht Dürer. *Wing of a Blue Bird*. Albertina Museum, Vienna. 197 x 200 mm (practically a square palm); watercolor and gouache on parchment, painted in 1512, this is one of Durer's last watercolors. Admire the richness of color and the incredibly precise drawing.

6

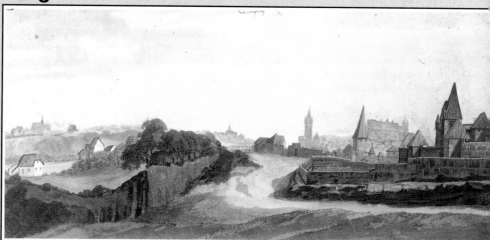

7

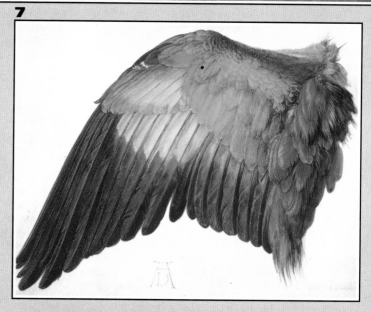

Washes as a Means of Study

Before and after **Dürer**, for four hundred years, nobody painted watercolors using all the colors; all the Renaissance and Baroque artists, from **Bellini** at the start of the XV century, to **Rubens** in the XVII, painted in watercolor on a small scale, but only with one color, that is to say with sepia color washes. Using this medium they painted the rough drafts of their oil paintings or their tempera murals. All the painters —**Leonardo, Rafael, Michael Angelo, Carracci**, etc.— in this respect followed the teaching of the artist and educator **Cennino Cennini**: in his book *Il libro dell'Arte* written in 1390, he explains *"Shade forms with washes of ink, doing it with as much water as fits in a walnut shell and with two drops of ink"*.

In the adjoining illustrations you can see a fragment of the sketch or rough draft on a reduced scale of **Rafael**'s mural *The school at Athens*, painted in a sepia color wash, and the same fragment of mural painted *al fresco* in the Estancia de la Signatura del Vaticano (figs. 8 and 9). To see an example of sepia colour washes used as a means of study for an oil painting, look at figure 10, the *Sketch for above a door* by **Hannibal Carracci**, and the well-known wash by **Claudio De Lorena** *Landscape with a river: view of the Tiber from Mount Mario, Rome* (fig. 11).

8

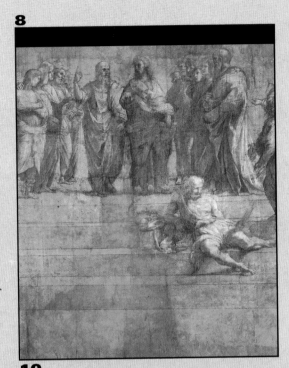

9

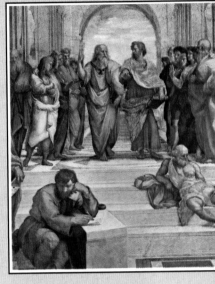

Fig. 10 (on the left). Hannibal Carracci (1560-1609). *Rough draft for above a door.* Museum of the Hermitage, St Petersburg. Painted with a sepia wash, intensified with carbon pencil and pen and ink and using white chalk, on gray colored paper; Carracci had already declared in the title of the picture, that it was a rough draft to decorate (presumably painting in oils), the top of a door.

10

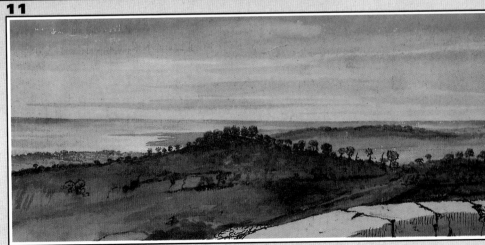

11

Figs. 8 and 9 (above). Rafael (1483 -1520). *The School at Athens* (fragment). Pinacoteca Ambrosiana, Milan. Rough draft on a reduced scale, painted in wash, and the same fragment (fig. 9), reproduced in the end product in *fresco*, painted by Rafael in the Estancia de la Asignatura, The Vatican, Rome.

Fig. 11 (on the right). Claudio de Lorena (1600-1682). *Landscape with river: View of the Tiber from Mount Mario, Rome.* The British Museum, London. Claudio painted up to eight studies in wash as sketches for each one of his great oil landscapes.

The XVII Century: the Rebirth of Watercolor

12

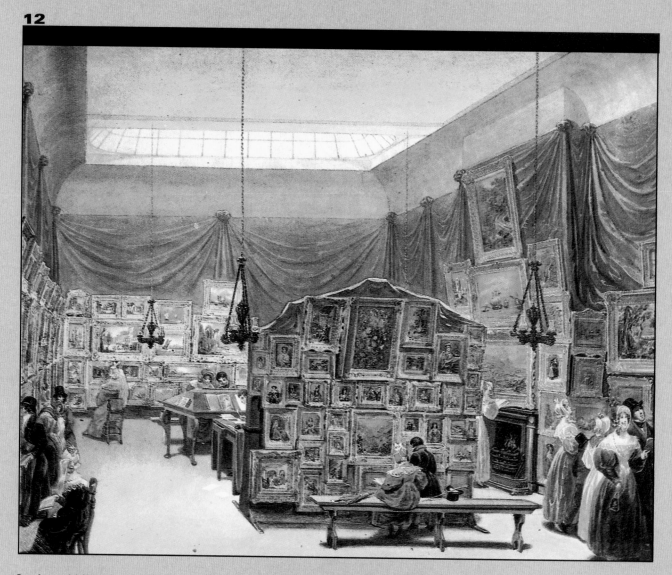

In the middle of the XVII century, well-bred English people liked to travel. There was what was called "The Grand Tour". It started in Paris, where they visited the Louvre museum. They then passed through Switzerland and finally ended up in Rome. These first tourists wanted a visual record to take back with them of the Eternal City. What better than a black and white print, a *veduta* (view) of the landscapes and ruins of ancient Rome?

In England they also printed copper engravings. Some editors thought that these prints were made more attractive by "illuminating" them with water-

colors. One of these illuminators was called **Paul Sandby**, and he is considered by the English to be "the father of watercolor painting". **Sandby** began to treat each reproduction as a unique piece of work. These were already true watercolors.

Paul Sandby and his brother **Thomas**, both watercolorists, were, amongst others, the founders of the English Royal Academy of Arts in 1768. However, the academy treated oil painters better than it did watercolorists. So, in 1804, they founded the Society of Watercolorists, which in 1808 had its second exhibition, the hall of which was reproduced in this

watercolor by **George Scharf** (fig. 12). Finally, in 1881, Queen Victoria decreed that the Society of Watercolorists could from then on use the title "Royal".

Fig. 12. George Scharf (1788-1860). *Exhibition of Paintings inside the Gallery of the New Society of Watercolorists.* Victoria and Albert Museum, London. The original of this extraordinary watercolor measures 29.6 x 36.7 cm; This small size meant that Scharf had to paint as an expert miniaturist, reproducing in the original picture some of the smallest water-colours measuring (including the frame) just 13 mm wide!

Turner, De Wint, Fortuny...

13

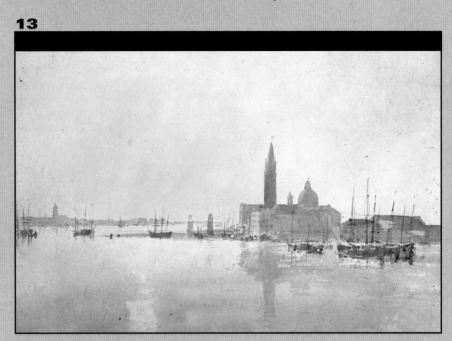

14

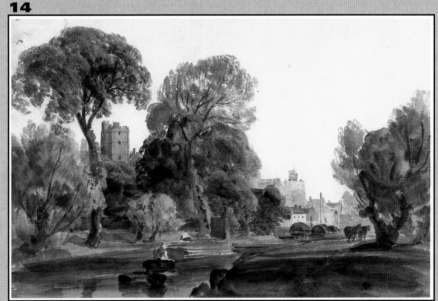

..And **William Pars, Francis Towne, Cozens, Blake, Fuseli**... And **Girtin, Cox, Cotman, Varley, Cristall, Callow, Samuel Palmer** and many others. In the XIX century watercolor painting was practised in England by thousands of enthusiasts. Of all the aforementioned the most important without a shadow of a doubt is **Turner**. **Joseph Mallord William Turner** was a precocious talent: when he was nine years old he had already illuminated prints for a commercial brewer. At thirteen he was apprenticed to the watercolorist **Thomas Malton**. When he was fifteen, the Royal Academy admitted one of his watercolors. When he was twenty-four he was admitted as an associate member of the Academy.

He alternated oil and watercolor and painted some of the most beautiful landscapes in the history of art (fig. 13). **Mariano Fortuny** (1838-1874) was a Spanish watercolor and oil painter. He is considered one of the best watercolorists of the XIX century. This fragment of his *Italian countrywoman* (fig. 15) is an example of his ability as a watercolor painter.

15

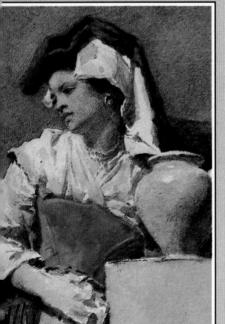

His contemporary **De Wint** (1784-1849) demonstrates in this adjoining watercolor (fig. 14), the strength of his coloring and his ability for synthesis.

Fig. 13. Joseph Mallord William Turner (1775-1851). *Venice, St George from the Aduana* **The British Museum, London. This is considered to be one of Turner's best watercolors because of its composition, its synthesis of forms, its luminosity and its harmony of color.**

Fig. 14. Peter de Wint. *The Thames at Windsor.* **Collection of the Royal Society of Watercolorists, London. De Wint paints here with a rough, sketchy technique, with lively, transparent brushstrokes particularly in the foliage of the trees.**

Fig. 15. Mariano Fortuny (1838-1874). *Italian countrywoman,* **25.2 x 17.8 cm (fragment). Private collection, Barcelona. Fortuny was an exceptional painter in all genres, but especially in drawing and painting figures, as you can see from the head and clothing of this countrywoman.**

Watercolor Today

16

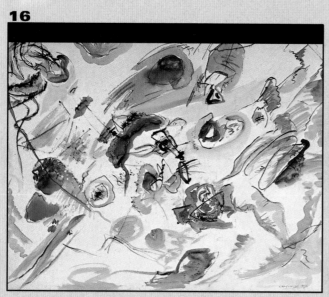

17

18

19

Fig. 16 (above). Vasili Kandinsky (1866-1944). *First abstract watercolor.* 1910. 50 x 65. The Georges Pomidou Center, Paris. Kandinsky, the first abstract painter, published the book *The Spiritual in Art,* in 1912, in which he announced abstract painting as pure composition.

Fig. 17. Childe Hassam (1859-1935). *The Canyon, Appledore*, 1912. The Museum of Brooklyn. An original theme painted with great dash and a chromatic strength which surprises the viewer.

Fig. 18. Andrew Wyeth (b. 1917). *Pirate country*, 1939. Norton Galleries and Art School, West Palm Beach, Florida. With the style of Sargent, Wyeth is considered in North-America to be one of the most popular watercolorists of our times.

Fig.19. Edward Seago (1910-1964). *Norfolk fields In winter.* Courtesy of David & Charles editorial, London. Seago, one of the most famous English watercolorists, had an extra-ordinary ability for drawing, which enabled him to paint directly, without first drawing

the subject, as in this landscape which is a magnificent example of synthesis.

Fig. 20 (next page). José M. Parramon (b. 1919). *Snow covered landscape.* Artist's collection. The white reserves and the light colors, the harmony and contrast of colors and the way the distant grounds are dealt with in blue-grey, are the most successful aspects of this picture.

20

From the middle of the last century painting has undergone a revolution of styles and forms. Starting with Impressionism, Pointillism or Divisionism, **Cézanne** —who is a revolution in himself— and continuing with "*les Fauves*" (the wild ones), Cubism, Surrealism, Pop Art, Abstract art, Non Figurative... Although imagination returned with a more meticulous conception than ever, that of **Antonio López**, and the North American Hiperrealists. Watercolor painting had kept a figuration and style close to that of Impressionism (in spite of the fact that the first abstract painting in history was actually a watercolor (fig. 16). It was painted by **Kandinsky** in 1910). Today watercolor painting, like painting in general, seems to have assimilated eclectically the lessons of the recent past. **Francisco Calvo Serraller**, who was director of the Prado Museum, expressed it very well when he was talking about present day art. He said: *"What we are living through now in art is not a creative era, but rather a scholastic era, i.e. a school which repeats, with some variations, what previously, between 1910 and 1920, were fundamental principles".*

21

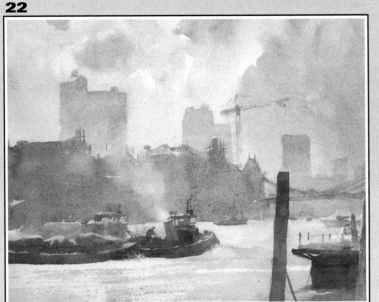

Fig. 21. John Singer Sargent (1856-1925). *Mountain River*. Museum of Metropolitan Art, New York. Famous watercolor and oil painter. Born in Italy of North American parents; he became famous for his portraits and his splendid watercolors.
Fig. 22. Trevor Chaimberlain. *Traffic on the Thames*. Courtesy of David & Charles editorial, London. Chamberlain knew how to capture the feeling of space with extraordinary clarity, using contrast and atmosphere.
Fig. 23. John Marin (1870-1953). *The Singer Building*. The Museum of Philadelphia. Born in North America, in 1905 he travelled to Paris where he met Whistler who influenced his watercolor painting.

22

23

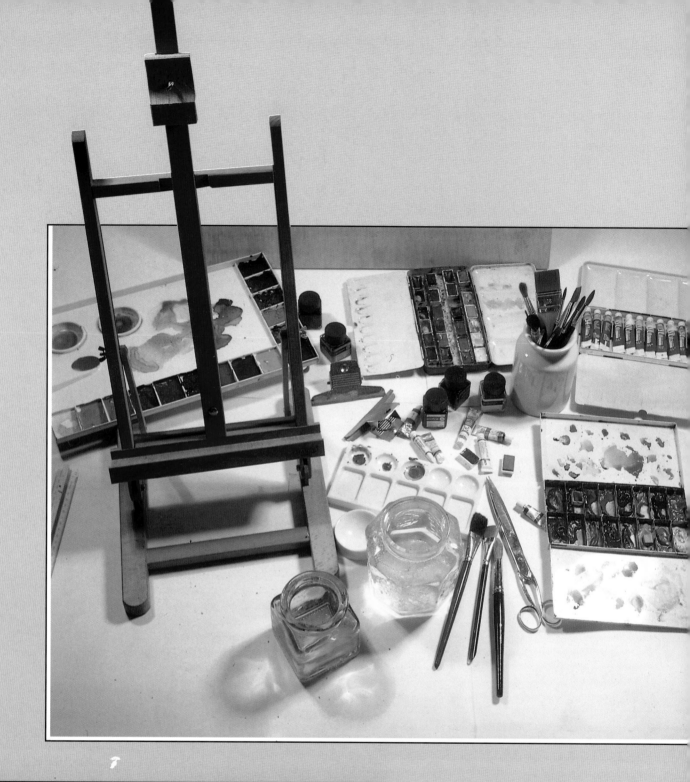

Fig. 24. Materials and tools for painting with watercolor.
Here is a photograph of the most commonly used: easel,
paints, palette, paintbrushes, paper, water, a roll of
absorbent paper, cloths...

MATERIALS
AND TOOLS

"The first tool of work (whether of an architect, a strate-gist, or a diplomat), is a table on which he can spread things out". This was written by the French philosopher Jean Guitton many years ago. More recently, the great Spanish realist painter, Antonio López said: "What is valuable is your time. The materials which we painters use hardly cost a thing, only time matters, that is your life". What Guitton and López say complement each other, painting is, first and foremost, about conquering a space to do it in. Next it's about knowing how to use materials and tools and not being thrown by them. Then all that's left is to paint. To dedicate the time you want to the pure pleasure of painting.

The Studio

Leonardo da Vinci said that *"a small room catches the spirit"* and that painting *"should be done by the light of just one window"*. This is what **Vermeer** did later (fig. 27, on the opposite page). However, the important painters of the past usually had big studios (fig. 28). Many painters nowadays paint in a room roughly 4 x 5 m, like the watercolorist **Gaspar Romero** (fig. 29).

Now that we are ready to work as efficiently as possible, here, in fig. 25, is what could be the ideal studio. In it, in addition to the basic element: the table (disussed on page 21), you can see a tripod table top easel, and a side table, a cabinet with drawers and wheels, the workshop easel is on the right, and behind it a unit with a light and a piece of glass for tracing, looking at slides, etc. On the left you can see a music system and above some bookshelves.

The lighting starts with the white walls, and the daylight which enters through the windows. You also have to be careful with the artificial light so that you can work at night. Install a ceiling light with four florescent tubes, two with a warm light and two with a cold light; add a table lamp, with a 100 watt bulb and an atmospheric light in the corner where you can relax. Running water in the studio? It's an unnecessary luxury. In the studio in my country house I have a typical ceramic washbasin (fig. 26). However it is a luxury which the kitchen tap can supply. We are going to talk in some detail, about these elements and tools over the next few pages. But first, take a look at artists' studios from past and present (figs. 27 to 31 on the opposite page).

25

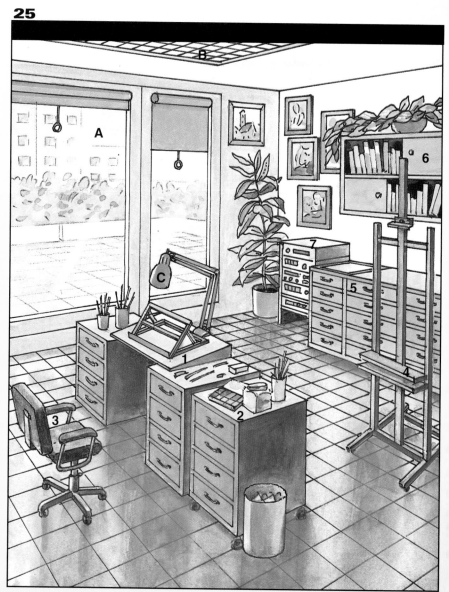

Fig. 25. Here is an ideal study, about 4 x 5 m, in which there is: 1. The table, on which we see a table top easel; 2. A side table, with wheels; 3. A chair with wheels; 4. A standing easel; 5. Unit; 6. Bookshelf; 7. Music system. Regarding the lighting: A. Wide windows; B. Fluorescent light; C. Table top lamp.

Fig. 26. In the studio in my country house there is running water with this ceramic washbasin which is decorative as well as being useful.

26

27

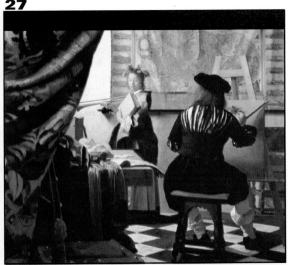

28

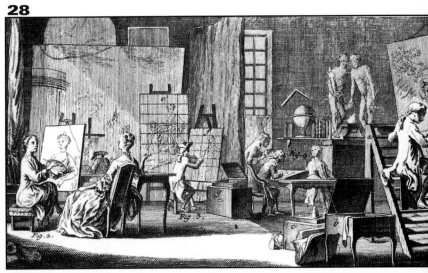

29

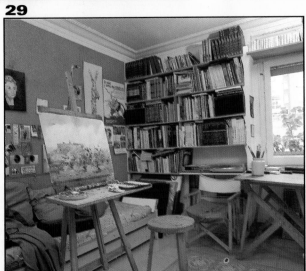

Fig. 27. Jan Vermeer (1632-1675). *Allegory on the art of painting* (fragment). Museum of History, Vienna. Vermeer here painted his studio, with the model, the picture and himself, lit with lateral lighting.

Fig. 28. *The painter's workshop*. An engraving by Benard of one of Prevost's drawings, which was published in the Encyclopaedia of Diderot. The National Library, Paris. Notice the curious detail of the apprentice, sitting in the center, painting on a gridded canvas.

Fig. 29. It is totally normal for the studio of a water-colorist, who generally paints in the open air, to be quite small, like this one, which belongs to the painter Gaspar Romero.

Figs. 30 and 31. My studio in my country house and my studio in Barcelona, both with lots of natural light thanks to large windows which produced filtered light from above.

30

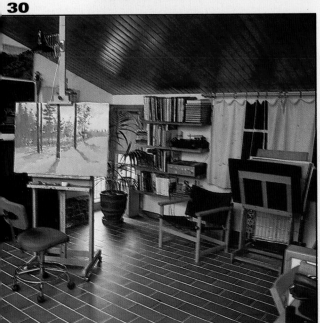

31

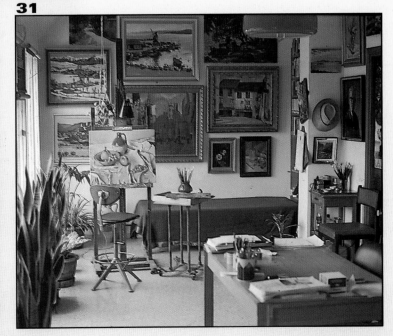

Furniture and Tools

Let's start with the table, and let's say right at the start, that a table for drawing and painting does not have to be a special table. Any ordinary table will do. For example, an office table, with drawers to keep things in. However, it would be best to see this as provisional. Professionals usually prefer a table which has been specifically designed for drawing, with an inclinable top, and adjustable height, such as the models in figures 34 and 35 which are made by Imasoto and Rocada; you will see in the foot notes to these pictures the characteristics that make these tables the most special of all the professional tables.

The table in figures 40 and 41 is specially made to order, it is made of wood and it consists of two blocks of drawers, which are independent, with an inclined drawing board in the middle which is also independent, as you can see in figure 41. With all this you have a table of adjustable width, depending on the needs of the user and the work. The drawers are quite deep, so much so that one of them, half open with a small board on top, can serve as a side table.

You can see above, in figure 32, two models of tabletop easel, the most recommendable one is the one on the right. In the next figure 33, a scissor bookrest to hold large files of paper and finished pieces of work to show to friends or clients.

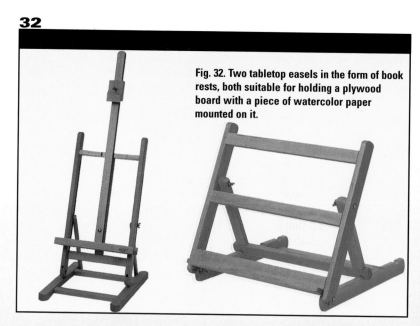

32

Fig. 32. Two tabletop easels in the form of book rests, both suitable for holding a plywood board with a piece of watercolor paper mounted on it.

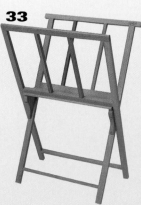

33

Fig. 33. Scissor style book-holder, to store blank paper, or to keep and display finished watercolors to friends or possible clients.

Fig. 34 (below). Drawing table, Ima Study model, courtesy of the makers Imasoto. The board is raised and inclined with automatic mechanisms; the minimum height is 70 cm, the maximum height is 110

cm. The table measures 90 x 130 x 100 x 150.

Fig. 35 (below). Drawing table, model RD190, courtesy of the makers Rocada. The height of the table is altered using the two knobs on the legs of the table (minimum height 74 cm, maximum height 126 cm). The table is inclined manually using the lever on the right hand side.

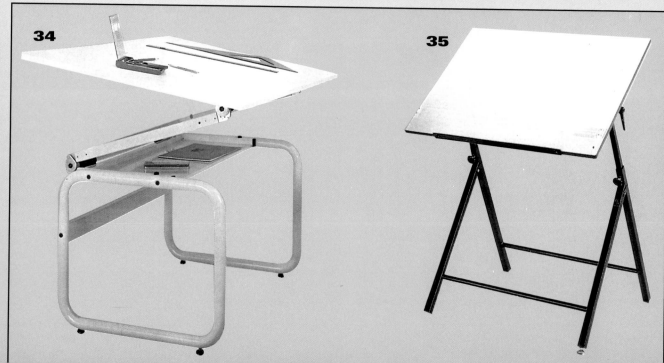

34

35

Here on this page, on the right you can see a metal unit composed of two parts, with tray-drawers, made by the firm Imasoto. You can read the characteristics of this unit in the footnotes which go with fig. 26, the drawers measure 124 x 91 cm, which means they can hold pieces of paper measuring 100 x 70 cm. This unit can be bought in the main shops which sell articles for drawing and painting. The side table with wheels, to put your paints and palette on, and the pot of water, paintbrushes, sponge, etc., can be a cabinet with drawers (fig. 37), or a metal table with a wooden top, also on wheels, the kind that is used in the home to keep vegetables in (fig. 38). Next to this we can see a chair with wheels and arm rests (fig. 39), and below, the special table we talked about before.

36

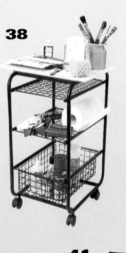

Fig. 36. Side unit, made of metal, by the company Imasoto, to file drawing or watercolor paper, sketches, projects and finished work. In this picture it is made of metal, with a top, base and two modules of five drawers each. The external measurements are: 133 x 95 x 96; the usable space in each drawer: 124 x 91 x 4.5 cm.

Fig. 37. A cabinet side table to have your materials and utensils at hand for painting. It has four drawers to store material and wheels to move it to wherever it is needed.

Fig. 38. One of the utensils that housewives have in the kitchen to store vegetables and fruit can serve as a side table, with shelves and wheels and with a board on top to hold the palette, the watercolors, the water, the paintbrushes etc.

Fig. 39. Drawing, painting, reading, sorting... and more things, can be done sitting down, and the best thing for this is a good armchair on wheels.

Figs. 40 and 41. Here is a specially ordered table, wich I mentioned on the previous page. It has two sets of four drawers and a fixed table-top, leaning slighty and independently from the drawers, so that they can be united or separated more or less. It is so solid that one drawer can be kept half open and, with a board rested upon it, becomes an auxiliary shelf.

37
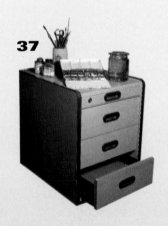

38

39

40
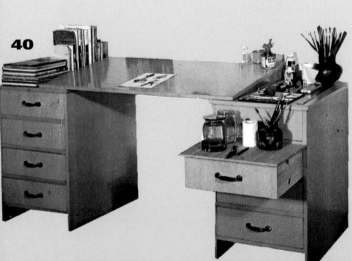

41
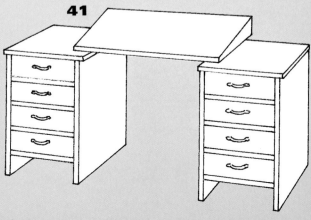

Studio Easels

Let me say first that the easels shown here in figure 42 and 43, are really field easels, that is to say, for painting in the open air, not studio easels. However, I and many other professionals often use them in the studio for painting smaller sized watercolors. They are the old, classic box-easels ideal for painting in oils. This model is the Italian version (fig. 42), which is narrower than normal and is better known in a wider format (fig. 43).

The rest of the easels on this page (figs. 44 and 45) are studio easels for painting in oils, which are also used for painting watercolors in the studio, by incorporating a board and paper instead of a canvas. The model in figure 45 obliges one to paint with the board in the vertical position, something which is completely normal for an expert watercolorist. The model in figure 44, made in England, allows the upper arm, where the board with the watercolor paper is placed, to be inclined when wanted.

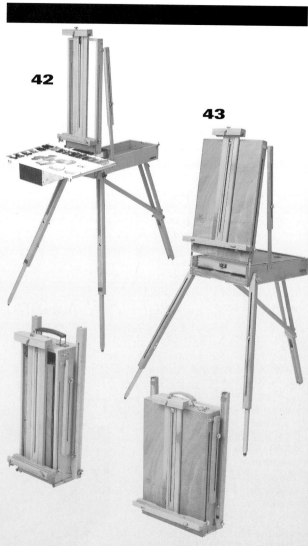

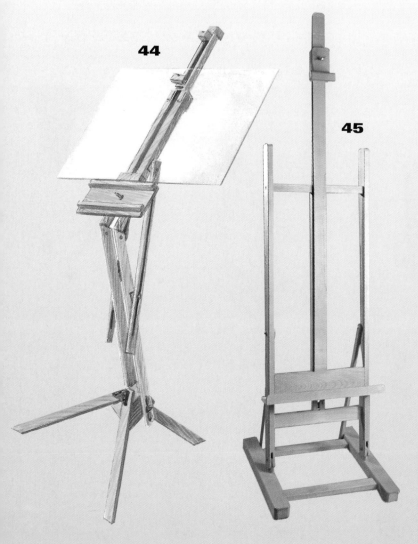

Figs. 42 to 45. From left to right, the two first are the box-easels, all one piece, foldable, the Italian model is narrow, and the normal model is wide. It is the classic easel, more than a hundred years old, and it is useful for painting both in oil and in watercolor. It can be used for painting in the studio or for painting in the open air, which is what it was actually invented for. The easel in figure 44 is an English model, for the studio, with articulation which allows you to incline the support and hence the board with the paper, if painting in watercolor, or the canvas, if painting in oil, whenever you want. The last, figure 45, is the classic studio easel, vertical, rigid, for painting in oil, though on occasions it can also be used for painting in watercolors.

Paper for Watercolor Painting

The quality of watercolor painting depends a great deal on the quality of the paper, to be precise the quality of the raw materials, the process of fabrication, the grain, the sizing and thickness of the paper. Modern quality paper is made from wood pulp using mechanical processes, it has hardly any grain and it is insufficiently sized. High quality papers are made with machines that imitate the manual process and with pulp that contains 100% canvas. The thickness of quality papers ranges between 250 and 350 grams per square meter; the sizing is effective and identical on both sides (so the artist can paint on both sides) and, regarding the grain, there are three classes of texture or types of finish:

Fine grain paper (fig. 47A)
Medium grain paper (fig. 47B)
Coarse grain paper (fig. 47C)

Fine grain paper is used by professional experts, to paint notes or small pictures. This paper dries rapidly, which means you need a certain amount of experience in controlling the wetness of the paper and so controlling the limits and blending. This paper is not recommended for beginners.

Medium grain paper takes away the need to work quickly and allows for greater control of the watercolor in general. This paper is fine for amateurs.

Coarse grain paper is generally used by professionals because it dries more slowly and its rough texture helps the development and the technical resolution of the watercolor.

The makers distinguish quality papers by the logotype, a stamp, dry engraved in one of the corners of the paper, or by the watermark, which is visible on one side of the paper when it is held up to the light.

46

Fig. 46. The makers distinguish quality papers, for drawing or watercolor, with relief stamps or with watermarks. To see the watermarks, in one corner, or on one side, you have to hold the paper up to the light.

Fig. 47A, B and C. The same subject painted on fine grain paper (A), medium grain paper (B), and coarse grain paper (C), shows a similar end result on different textures.

47A

47B

47C

The Presentation of the Paper

Paper for watercolor painting comes in single sheets (fig. 48), in sheets mounted on cardboard (made by Schoeller: 51 x 72 and 70 x 100 cm) which prevents the wetness warping the paper while you paint, in rolls of 1.52 x 10 m or 1.13 x 9.15 m, and in blocks of 10, 20 or 25 sheets stuck on all four sides to keep them taut while you paint. The size of these blocks goes from the smallest, 10.5 x 15.5 cm, to the largest, 65 x 90 cm, and in each size there are papers of fine, medium and coarse grain.

The most typical sizes of paper in Europe are the following:

50 x 70, half sheet

70 x 90, full sheet

These sizes can vary by a few centimeters more or less. The make Fontenay, of Canson, for example, offers only two sizes, in thick 300 gram paper; size 55 x 75 cm and size 75 x 110 cm.

These sizes are not the same in other countries.

In Britain paper is still available in six traditional sizes, ranging from what is called Royal Half (381 x 559 mm) to the largest Antiquarian (787 x 1.346 mm).

The thickness of the paper is measured in weight. The traditional unit in paper is the ream, which is 500 sheets, whatever the size of each sheet. The weight of the ream converted into grams per metre squared determines its thickness. So, paper 50 g per square meter is thin paper which will take hardly any water. Paper 350 g per square meter is thick paper, similar to cardboard, which will stand water very well.

48

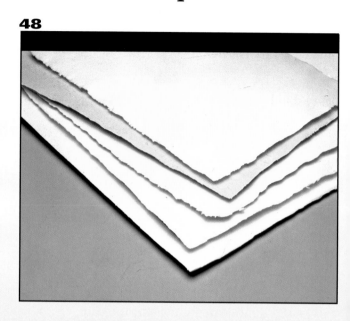

49

Fig. 48. Watercolor paper comes in individual sheets and in sheets mounted on thick cardboard in sizes of 51 x 72 and 70 x 100 cm (Schoeller), which removes the work of tautening the paper. The sizes of paper in sheets in Europe, are 35 x 50, 50 x 70 and 70 x 100. Watercolor paper which is hand-made or by methods like those of making paper by hand, has characteristic "barbs" in its finish, with irregular, thinner edges.

Fig. 49. Watercolor paper also comes in blocks of 20 or 25 sheets, mounted on cardboard and stuck at all four sides in the form of binding which means you don't have to mount and tauten the paper to avoid wrinkles and warping due to the wetness of the washes of watercolor. These come in sizes of up to 65 x 90 cm.

MAKES OF QUALITY PAPER FOR WATERCOLOR PAINTING

Canson & Montgolfier	France
Arches	France
Schoeller Parole	Germany
Whatman	UK
Grumbacher	USA
RWS	USA
Guarro	Spain
Fontenay	Spain

Tautening the Paper

Like the famous quotation from **Shakespeare**'s *Hamlet*: *"To tauten or not to tauten? That is the question"*. There are watercolorists who wet the paper again and again under a tap, and who tauten it by sticking it with strips of tape to a chipboard board (figs. 50, 51 and 52). However, there are other watercolorists, quite a few of them in fact, who don't, who think that this business of mounting the paper and leaving it to dry *"is a silly waste of time"*, in the words of **Pepe Martínez Lozano**, president of the Catalonian Watercolorist Association. However, we must make some points clear, and clear up any doubts. Point one: It is necessary to tauten the paper when you want to paint a large watercolor (more than 50 x 70 cm). Point two: when the paper is thick (350 g) and the size of the watercolor is quite small (less than 50x35cm), it is not necessary to tauten the paper with strips of sticky tape, you can hold it in place with drawing pins. Now look at figure 55, and notice the curious method of the watercolorist **Ballestar**, who wets the paper and mounts it and tautens it with a stapler on an oil painting frame. **Ballestar** says that besides being practical, this system makes it easier to calculate the watercolor's price, according to the staples used: a number 12 frame, twelve staples, $65 a staple, means that the selling price is $780.

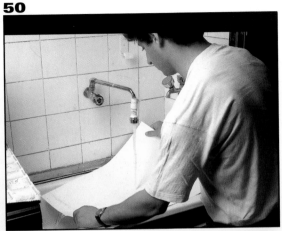

50

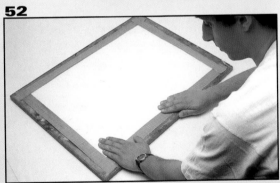

51

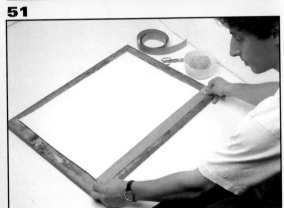

52

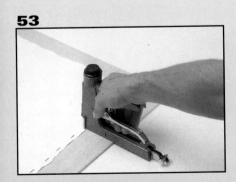

53

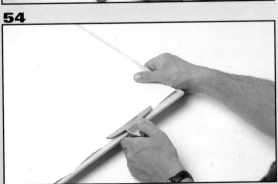

54

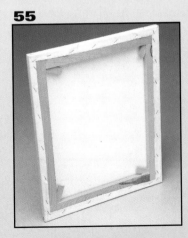

55

Fig. 50. With papers thinner than 250 g it is necessary to wet, mount and tauten the paper. So start by wetting the paper on one side under the tap for one or two minutes.

Fig. 51. Put the wet sheet of paper on a board and stick the first edge of the sheet to the board.

Fig. 52. Next it is a question of sticking the other three sides to the board with sticky tape and then leaving the board and the paper in a horizontal position to wait for it to dry.

Fig. 53. You can tauten the paper by attaching it to the board with a staple gun.

Fig. 54. If the paper has a thickness of 300 g or more, and the watercolor is medium sized, you can hold the paper to the board with drawing pins or good clips.

Fig. 55. Wetting the paper and tautening it with staples, on a wooden frame, is another method used by my friend Ballestar, a watercolorist.

Watercolor Paints

Watercolor paints are composed of pigments with an animal, vegetable or mineral origin, mixed and bound with water and gum Arabic plus glycerine and honey and a preserving agent. The glycerine and honey are to ensure that the thickest layers of paint don't crack when they dry. Watercolor paints come commercially in four different presentations:

<div align="center">

Pans of dry watercolor

Pans of wet watercolor

Tubes of cream watercolor

Bottles of liquid watercolor

</div>

Pans of dry watercolor (figs. 57 and 57A). Also called "godets" (is a French word and means small container, cup or jug). Pans of dry watercolor, made of porcelain or

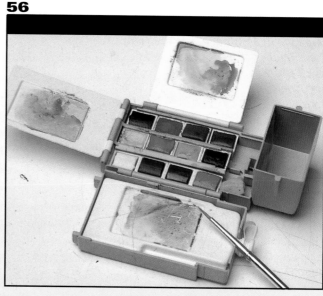

56

Fig. 56. Miniature palette box, with pans of wet watercolor, paintbrush and a small container for water, made by the English firm Winsor & Newton, especially for sketching.

Fig. 58 (left). Pans of wet watercolor, of superior quality, square or rectangular depending on the make. They come in palette boxes of 6,12 and 24 colors and you can also buy individual pans.

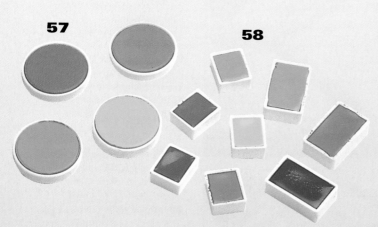

57

58

plastic and usually round. Inside each pan is a small amount of dry paint. Dry watercolor paint of school quality is the cheapest kind. The paints come individually.

Pans of wet watercolor paint (fig. 58). This is the quality of watercolor paint used by professionals, it comes in little white containers which are square or rectangular, depending on the make.

The pigment of wet watercolors is of a superior quality, and the paint contains more glycerine and honey (this is why the paints are wet). Because the paints are wet they dilute more quickly and so painting with them is easier and nicer. They come in metal palette boxes of 6, 12, and 24 colors, and you can also buy colors individually.

Fig. 57 and 57A. Round pans of dry watercolor, and a palette box with the same sort of godets (57A), economically priced, considered to be of average or school quality.

Fig. 59. Tubes of cream watercolor, of equally superior quality, they come in tin tubes like oil paints do. The most used tube size is number three, which has a capacity of eight cubic centimeters. The 14 colors, reproduced here are a selection which is commonly used by professionals. We talk about this selection on page 30.

57A

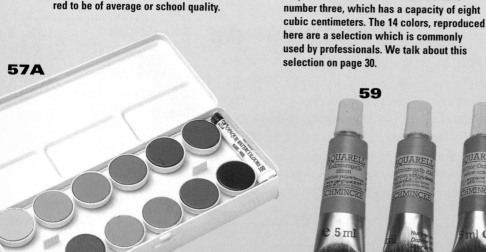

59

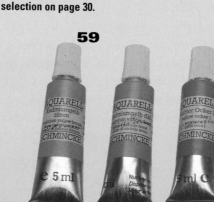

Tubes of cream watercolor paint (fig. 59). The paint, which is a thick cream, comes in tin tubes, like oil paint, and its quality is equally superior, and used by professionals. Cream watercolor is diluted at the moment you need it with water and produces the same transparency as the wet paint in godets. It normally comes in pallet-boxes of 12 tubes. The largest size of tube is the number 3, which contains 8 cubic cms of cream paint. Like the godets of wet paint, tubes of watercolor can also be bought individually.

Bottles of liquid watercolor paint (figs. 60 and 61). These are most commonly used by graphic designers, and not generally by professional watercolorists. However some painters use liquid watercolor to paint backgrounds or wide degradings.

So, let's take the godets of wet watercolor and the tubes of cream watercolor. Which of these would a professional choose? They are both good mediums, in the end it is all down to habit or custom. You should remember that if you use cream watercolor, you have to use a palette, and when the colors dry they are no longer cream and then they are exactly like the godets of wet paint.

What exactly is Chinese white used for?

So, have we said everything that needs to be said about the water-co-

speak of Reserving blank areas, and masking white areas, it being understood that these white areas are blank areas of paper and that in the pure, traditional watercolor, you can't use the color white because it is opaque, which breaks the idea of transparency, the fundamental characteristic of watercolor.

So why then, in boxes of wet watercolor or watercolor in tubes, is there always a tube of white, which is opaque, and is named *Chinese white?* Nobody knows, nobody understands. The professional would tell you that to use the Chinese white is a sacrilege and that for reserving very complicated areas, there already exists the technique of mask with latex, and then scraping it with a cutter, or with sandpaper, or a shaving blade. So?

The only explanation is that the making of watercolors in godets was started in 1835 by the Englishman **Winsor** (who five years later became partners with Mr. **Newton** and founded **Winsor & Newton**, which still exists today, and still makes watercolor paints) In at this time, the XIX century, we know that **Turner** and other watercolorists of the time, painted some watercolors using white when, for example, they were painting on paper which had previously been dyed blue, grey, cream, etc. They then used the color white to create white and bright areas. It is therefore supposed that **Winsor & Newton** included Chinese white to attend to the way of painting at that time, and it has stayed as part of the range of colors, for anyone who wants to use Chinese white today.

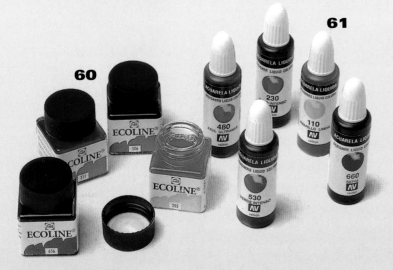

60

61

Figs.60 and 61. Bottles of liquid watercolor, a medium little used by watercolorists. Talens make Ecoline (fig.60); the French company Lefranc make Fluidine and in Spain the manufacturer is Vallejo (fig. 61) I cite these makes because Aerocolor or Magic Color are sometimes cited as liquid watercolor, when in fact they are denser colors, especially for airbrushing, but not for watercolor painting.

lour paints?, Yes, but... there is still one thing left which can cause confusion, and this seems a good opportunity to make it clear, as part of the lesson, and part of the history of watercolor.

Throughout this *Practical Course in Watercolors*, we will say on several occasions that the white in watercolor is the white of the paper, and we will

A Chart of Watercolor Paint Colors

This a chart of watercolor colors that we publish with the kind permission of the manufacturer Schmincke. There are a total of 81 different colors, it is incredible. With only the yellows, oranges, reds and carmines there are 30 different colors, when in reality you only need three: cadmium yellow lemon, cadmium red and madder carmine. So how do you explain the immense variety of different colors and shades? The answer is relatively simple: "Every great teacher has his book", which in this case means "Every painter has his palette". In my palette, there are three blues: Prussian blue, cobalt blue and ultramarine blue. Well, I know a watercolorist friend of mine who paints with cerulean blue and doesn't use Prussian blue because he says it isn't a very permanent color. In conclusion, there are those who paint with a very limited palette and there are those who think you need more than fifteen different colors. I have come to the conclusion that only twelve colors are necessary

Going back to the color chart, as you will see, next to the number of each color, there are stars (between two and five). These indicate the degree of solidity or permanence of the color, its resistance to light. The more stars the greater the resistance. Bear this in mind but don't become obsessed with it: the National Gallery in London exhibits watercolors which are more than a century and a half old, and the color in them is still good. This being so, all watercolor paints lose ten to twenty percent of their luminosity between the moment they are applied and their definitive dry state. You must count on this happening.

Fig. 62. Chart of paint colors of the manufacturers Schmincke published with their kind permission. With a total of 81 different colors the artist can choose their palette, i.e., the yellow, red, blue, etc, that best fits their way of seeing and painting color.

62

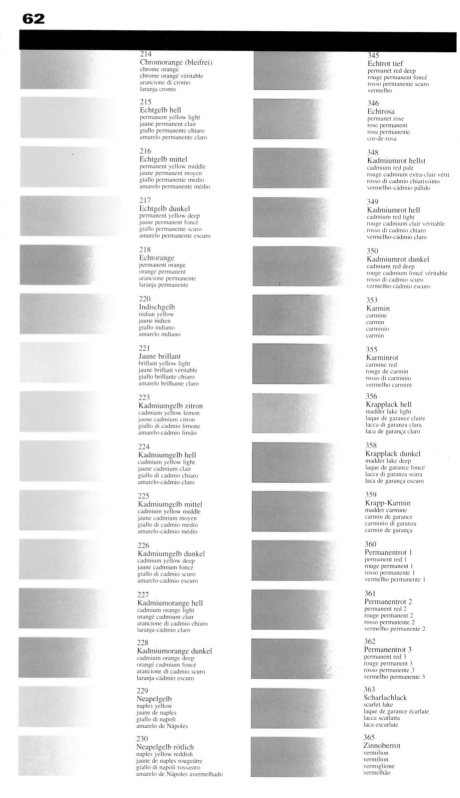

214
Chromorange (bleifrei)
chrome orange
chrome orangé véritable
arancione di cromo
laranja cromo

215
Echtgelb hell
permanent yellow light
jaune permanent clair
giallo permanente chiaro
amarelo permanente claro

216
Echtgelb mittel
permanent yellow middle
jaune permanent moyen
giallo permanente medio
amarelo permanente médio

217
Echtgelb dunkel
permanent yellow deep
jaune permanent foncé
giallo permanente scuro
amarelo permanente escuro

218
Echtorange
permanent orange
orangé permanent
arancione permanente
laranja permanente

220
Indischgelb
indian yellow
jaune indien
giallo indiano
amarelo indiano

221
Jaune brillant
brillant yellow light
jaune brillant véritable
giallo brillante chiaro
amarelo brilhante claro

223
Kadmiumgelb zitron
cadmium yellow lemon
jaune cadmium citron
giallo di cadmio limone
amarelo-cádmio limão

224
Kadmiumgelb hell
cadmium yellow light
jaune cadmium clair
giallo di cadmio chiaro
amarelo-cádmio claro

225
Kadmiumgelb mittel
cadmium yellow middle
jaune cadmium moyen
giallo di cadmio medio
amarelo-cádmio médio

226
Kadmiumgelb dunkel
cadmium yellow deep
jaune cadmium foncé
giallo di cadmio scuro
amarelo-cádmio escuro

227
Kadmiumorange hell
cadmium orange light
orangé cadmium clair
arancione di cadmio chiaro
laranja-cádmio claro

228
Kadmiumorange dunkel
cadmium orange deep
orangé cadmium foncé
arancione di cadmio scuro
laranja-cádmio escuro

229
Neapelgelb
naples yellow
jaune de naples
giallo di napoli
amarelo de Nápoles

230
Neapelgelb rötlich
naples yellow reddish
jaune de naples rougeâtre
giallo di napoli rossastro
amarelo de Nápoles avermelhado

345
Echtrot tief
permanet red deep
rouge permanent foncé
rosso permanente scuro
vermelho

346
Echtrosa
permanet rose
rose permanent
rosa permanente
cor-de-rosa

348
Kadmiumrot hellst
cadmium red pale
rouge cadmium extra-clair vérit
rosso di cadmio chiarissimo
vermelho-cádmio pálido

349
Kadmiumrot hell
cadmium red light
rouge cadmium clair véritable
rosso di cadmio chiaro
vermelho-cádmio claro

350
Kadmiumrot dunkel
cadmium red deep
rouge cadmium foncé véritable
rosso di cadmio scuro
vermelho-cádmio escuro

353
Karmin
carmine
carmin
carminio
carmin

355
Karminrot
carmine red
rouge de carmin
rosso di carminio
vermelho carmim

356
Krapplack hell
madder lake light
laque de garance claire
lacca di garanza chiara
laca de garança claro

358
Krapplack dunkel
madder lake deep
laque de garance foncé
lacca di garanza scura
laca de garança escuro

359
Krapp-Karmin
madder carmine
carmin de garance
carminio di garanza
carmin de garança

360
Permanentrot 1
permanent red 1
rouge permanent 1
rosso permanente 1
vermelho permanente 1

361
Permanentrot 2
permanent red 2
rouge permanent 2
rosso permanente 2
vermelho permanente 2

362
Permanentrot 3
permanent red 3
rouge permanent 3
rosso permanente 3
vermelho permanente 3

363
Scharlachlack
scarlet lake
laque de garance écarlate
lacca scatlatta
laca escarlate

365
Zinnoberrot
vermilion
vermilion
vermiglione
vermelhão

480
Bergblau
mountain blue
bleu de montagne
blu di montagna
azul montanha

481
Cölinblau
cerulean blue
bleu ceruleum véritable
blu celeste
azul celeste

483
Echtviolett
permanent violet
violet permanent
viola permanente
violeta permanente

484
Phthalobau
phthalo blue
bleu phthalo
blu phthalo
azul phthalo

485
Indigo
indigo
indigo
indaco
indigo

486
Kobaltblau imit.
cobalt blue imit.
bleu de cobalt imit.
blu di cobalto imitazione
azul cobalto rescuro

487
Kobaltblau hell
cobalt blue light
bleu cobalt clair véritable
blu di cobalto chiaro
azul cobalto claro

488
Kobaltblau dunkel
cobalt blue deep
bleu cobalt foncé véritable
blu di cobalto scuro
azul cobalto escuro

389
Kobaltviolet dunkel
cobalt violet deep
violet cobalt foncé véritable
viola di cobalto scuro
violeta cobalto escuro

490
Magenta
magenta
magenta
vila di magenta
magenta

491
Pariserblau
paris blue
bleu de paris
blu di parigi
azul paris

492
Preußischblau
prussian blue
belu de pusse
blu di prussia
azul prússia

493
Purpuviolett
purple violet
violet pourpre
viola porpora
violeta púrpura

494
Ultramarin feinst
ultramarine finest
outremer extra-fin
blu oltremare finissimo
ultramarino fino

495
Ultramarinviolett
ultramarine violet
violet outremer
viola oltremare
violeta ultramarino

496
Ultramarinblau
ultramarine blue
bleu outremer
blu oltremare
azul ultramarino

497
Violett feurig
glowing violet
violet lumineux
viola luminoso
violeta luminoso

516
Grüne Erde
green earth
terre vert
terra verde
terra verde

517
Grünlack hell
green lake light
laque vert clair
lacca verde chiara
laca verde claro

518
Grünlack dunkel
green lake deep
laque vert foncé
lacca verde scura
laca verde escuro

519
Phthalogrün
phthalo green
vert phthalo
verde phthalo
verde phthalo

520
Hookersgrün 1
hooker's green 1
vert de hooker 1
verde di hooker 1
verde hooker 1

521
Hookersgrün 2
hooker's green 2
vert de hooker 2
verde di hooker 2
verde hooker 2

522
Kobaltgrün hell
kobalt green light
vert cobalt vlair vérit
verde di coblato chiaro
verde cobalto claro

523
Kobaltgrün dunkel
kobalt green deep
vert cobalt foncé vérit
verde di coblato scuro
verde cobalto escuro

524
Maigrün
may green
vert de may
verde primavera
verde primavera

525
Olivengrün
olive green
vert olive
verde oliva
verde oliva

526
Permanentgrün hell
permanent green light
vert permanent clair
verde permanente chiaro
verde permanente claro

527
Permanentgrün dunkel
permanent green deep
vert permanent foncé
verde permanente scuro
verde permanente escuro

528
Preußischgrün
prussian green
vert de pusse
verde di prussia
verde prússia

529
Saftgrün 1
sap green 1
vert forêt 1
verde bosco 1
verde bosque 1

530
Saftgrün 2
sap green 2
vert forêt 2
verde bosco 2
verde-seiva

531
Zinnobergrün hell
vermilion green light
vert cinabre clair
verde vermiglione chiaro
verdecinábrio claroa

532
Zinnobergrün dunkel
vermilion green deep
vert cinabre foncé
verde vermiglione scuro
verde cinábrio escuro

650
Englischrot dunkel
english red deep
rouge anglais foncé
rosso inglese scuro
vermelho inglês escuro

651
Goldocker
golden ochre
ocre or
ocra oro
ocre dourado

653
Grüne Erde gebrannt
burnt green earth
terre verte brûlée
terra verde bruciata
terra verde queimada

655
Lichter Ocker 1
yellow ochre 1
ocre jaune 1
giallo ocra 1
ocre amarelo 1

656
Lichter Ocker 2
yellow ochre 2
ocre jaune 2
giallo ocra 2
ocre amarelo 2

657
Lichter Ocker gebrannt
burnt yellow ochre
ocre jaune brûlée
giallo ocra bruciato
ocre amarelo queimado

658
Madderbraun
brown madder
laque de garance brun-rouge
lacca di garanza bruna
laca garança castanho

660
Siena natur
raw sienna
terre de sienne naturelle
terra di siena naturale
siena natural

661
Siena gebrannt
burnt sienna
terre de sienne brûlée
terra di siena bruciata
siena queimada

662
Sepiabraun col.
sepia brown tone
teinte sepia
tinta di seppia bruciata
tinta sépia

663
Sepiabraun
sepia brown
brun sepia
seppia bruciata
sépia

664
Stil de grain brun
brown pink
stil de grain brun
stil di grain bruno
stil'grão castanho

665
Stil de grain vert
green pink
stil de grain vert
stil di grain verde
stil'grão verde

666
Terra Pozzuoli
pozzuoli earth
terre de pouzzoles
terra di pozzuoli
terra pozzuoli

667
Umbra natur
raw umber
terre ombre naturelle verdâtre
terra d'ombra naturale
umbra natural

668
Umbra gebrannt
burnt umber
terre ombre brûlée
terra d'ombra bruciata
umbra queimada

669
Vandyckbraun
vandyke brown
brun van dyck
bruno van dyck
pardo van dyck

Frequently Used Colors

63

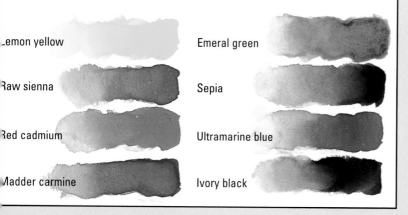

As the father of French *nouvelle cuisine*, **Paul Bocuse**, said, the important thing is not the menu, but the meal: *"The menu is offered so that with it the clients can put together their meal"*. However, the master watercolorists of the XVIII century like **Cozens, Girtin** and including **Turner** painted with a range of half a dozen colors (figs. 64 and 65). The most typical manufacturers "menu" usually contains twelve, like the standard box. But not any old twelve colors, twelve based on years of sales experience, i.e. the twelve most frequently used colors. You can achieve practically any hue with them. However, it is not necessary to be so puritanical. A couple of yellows, a red and a carmine, two greens, three browns or earth colours, the three traditional blues and two kinds of black (Payne gray and ivory black): here we have a sensible palette of 14 colors, which could be further reduced to 10 (fig. 63), leaving those colors marked with an asterix from the list. These are not "the obligatory twelve or fourteen", nevertheless, start with them. It is possible that with time you will leave one out or add another, and then you will have found your palette.

1. Lemon yellow	*8. Permanent green
*2. Cadmium yellow deep	9. Emerald green
3. Yellow ochre	10. Cobalt blue
*4. Earth umber	11. Ultramarine blue
5. Sepia	12. Prussian blue
6. Red cadmium	13. Payne gray
7. Madder cadmium	*14. Ivory black

Fig. 63. Here is a selection of colors considered to be commonly used. With very slight variations, this is the selection of colors typically used by professionals.

Fig. 64. These are the colors with which Thomas Girtin painted. There are eight in total.

Fig. 65. Thomas Girtin (1775-1802). *The white house in Chelsea.*

64

Lemon yellow	Emeral green
Raw sienna	Sepia
Red cadmium	Ultramarine blue
Madder carmine	Ivory black

65

Palette-Boxes

The hyphen which joins the two words says it all: this is a box of paints which contains built in to it a palette to mix the paints on. Most boxes are like this: made of metal covered in white enamel, containing godets of wet watercolor or tubes of cream watercolor (figs. 66 and 67). They are functional boxes which allow you to separate the paints from the box, thereby making two or three palettes available which have cavities and the ring to hold the palette with your thumb (at the point indicated by A), or the hole to hold the palette with your thumb again while you mix colors and paint. Holding the palette with your thumb is an option but not one usually used by professionals, they prefer to paint with the palette flat, resting on the table in the studio or in the easel box or on the tray of the easel if they are painting outside the studio.

66

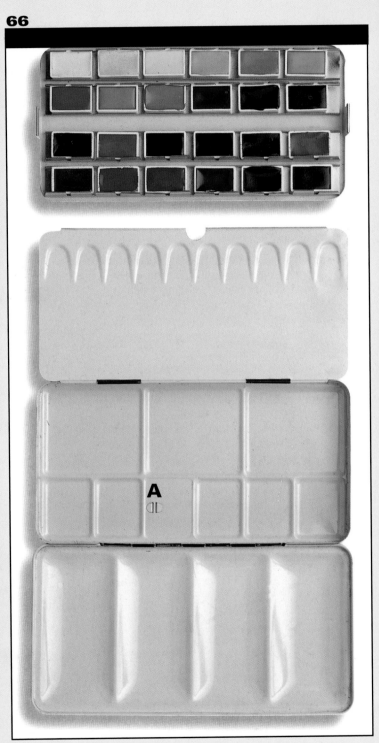

Figs. 66 and 67. The Schmincke box-palette, containing 24 godets of wet watercolor paint, and the Talens box-palette, with 12 tubes of cream paint. In both boxes, the plate which holds the paints can separate from the box-palette, so that you have extra space for mixing colors. Underneath in the middle of the Schmincke box-palette (the point marked A9, there is a ring to hold the box with your thumb. In the Talens box-palette there is a hole, in the lower palette, which serves the same purpose.

67

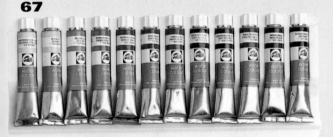

Individual Palettes

68

There are many watercolorists who refuse to accept the box-palettes offered by the manufacturers and prefer instead to choose the real, "personal" palette, whether for tubes of cream watercolor, (figs. 68 and 68A), or for godets of wet watercolor (fig. 68B). In either case, the main advantage of a personal palette, chosen by the artist is that as you can buy individual paints, it is the painter who determines the number and selection of colors.

With regard to the number of colors notice that in the palette of godets of wet watercolor (fig. 68B) there are a mere 28 colors! While in the palette for cream paints there are spaces for 15 and 16 colors (fig. 68 and 68A). Bearing in mind what has already been said about cream colors (that when they dry they are almost exactly like wet watercolors), I think the kind of palette-box used is irrelevant, as long as the number of cavities and therefore the selection of colors is not excessive.

Returning to the palette in the center, figure 68A, for cream paints, this is the most functional and the most commonly used by professional watercolorists, it is important to highlight these characteristics: it is metal and made up of three foldable parts which convert, when closed, into a box which is black enamelled on the outside, sized 21 x 11.5 cm. When you open and fold out the box, you find, in the center, sixteen cavities wich contain sixteen cream colors; and on both sides the two lids, enamelled in white as two palettes for mixing the colors. When the box-palette is open it measures between 34.5 x 21 cm. On the back there is ring to hold it with (plan 68A).

68A

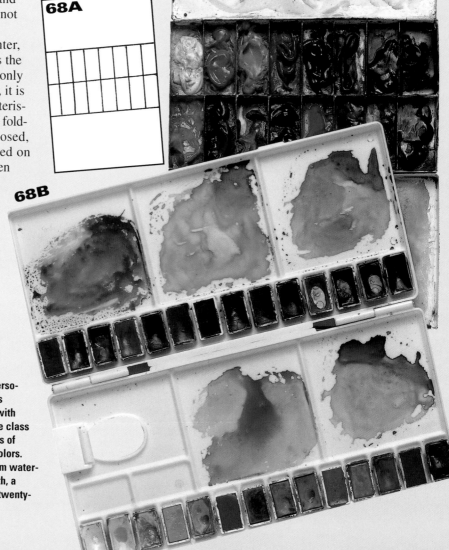

68A

68B

Figs. 68, 68A and 68B. Three individual or personal palettes, in the end, the artist is the boss over choosing the shape and the contents, with more or fewer colors, and with paints of one class or another. Above (fig. 68), a palette for tubes of cream watercolor, with spaces for fifteen colors. In the middle a second palette also for cream watercolor, with sixteen colours (68A). Underneath, a palette with pans of wet Watercolors, with twenty-eight colors (68B).

Water, Mediums, Masking Fluids...

There, at the foot of the page, you can see various bottles of different liquids. We are going to talk about the specific use of each one of them, but it is good to remember that the only essential one is water. Clean from the tap, nothing more than that.

To talk about water we also have to refer to the container. Glass for in the studio, plastic for painting outside the studio, so that it doesn't break. Some painters are advocates of having two containers, one, they say, for the clean water, another for dirty water for rinsing and cleaning paintbrushes. However there are plenty of artists against this practice, who work with just one container of water: they say it is better that the water gets a little bit dirty so that you can see better limits and contours when you wet an area, and anyway, lightly tinted water helps achieve a better harmonization of color.

Whatever they look like, the receptacles should have a capacity of one and a half liters, and a wide mouth. Jam jars are ideal (fig. 69).

Of all the liquid substances used in watercolor painting (fig.71), medium number 2 stands out. If you mix a few drops of this in the water, it eliminates any traces of grease, which increase the adherence and makes the colors brighter; ox gall for moistening, add a dash for every half liter of water; glycerine, a few drops to delay drying (fig. 70); 96% alcohol, a dash to accelerate the drying process; varnish to protect the colors and make them brighter; and liquid gum or masking fluid, which we have already talked about, for reserving small areas, thin lines and white or bright areas.

69

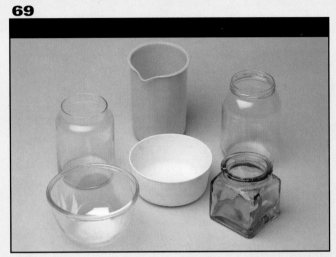

70

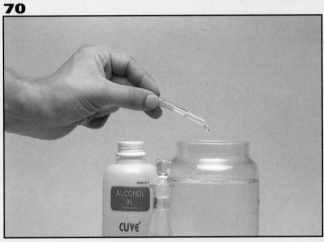

Fig. 69. Containers for water. Glass ones for the studio and plastic ones for painting outside the studio so that they don't break. They should hold at least half a liter of water and preferably a liter.

Fig. 70. To delay the drying process of the watercolor when the heat makes things difficult, you can put a few drops of glycerine in the water. And to accelerate drying, when it is cold and damp, a splash of alcohol... or of whisky as British watercolorists do!

Fig. 71. N.B: apart from the indispensable water, the other liquids which could be useful to you when painting with watercolors are: *medium no. 2, ox gall, glycerine, 96% alcohol, varnish and masking fluid.*

71

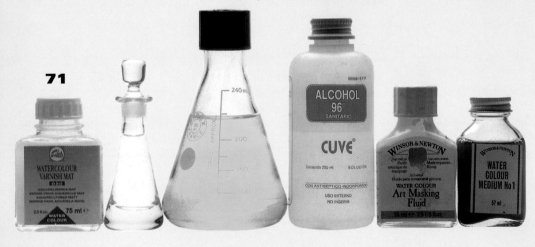

Paintbrushes: Different Classes of Brushes

Here on the right of this text (fig.72), you have all the necessary instruments, as far as paintbrushes go, to paint watercolor. Three sable hair paintbrushes: one number 5, one number 8 and the other number 12; one synthetic hair brush, number 8, and two broad brushes: one sable number 14 and one synthetic number 18. This is a good selection, you don't need any more than these. However, let's make things clearer about the difference between sable and synthetic, by starting with all the main different classes of paintbrushes (fig. 75):

Rounded paintbrushes made of synthetic hair
Broad brush: synthetic hair
Broad brush: sable hair
Broad brush and paint brush: ox hair
Paintbrush: mongoose hair
Paintbrush: deer hair (Japanese)
Paintbrush: polecat hair
Broad brush: squirrel hair

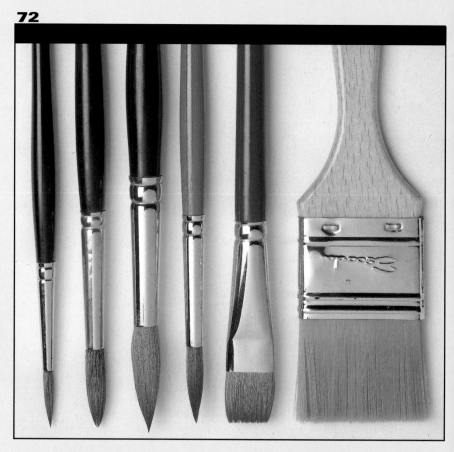

72

As you know a paintbrush is made up of a handle of varnished wood, into which is inserted the chrome ferrule, which in turn holds the base of the hairs. The quality of these hairs determines the quality of the paintbrush. All professionals agree that sable brushes are the best. They are also the most expensive. However, since paintbrushes using synthetic hair appeared, the supremacy of sable brushes has been reduced a little. *"Nowadays sable and synthetic brushes sell in the same proportions"* says **Vicenç Piera**, a seller who understands the subject, *"and sable ones cost twice as much as synthetic ones... But there's nothing like sable"*, he ends up by saying.
The great watercolorist **Guillermo Fresquet** defined the sable brush in this way: *"It is sponge-like, it can carry large amounts of liqued and color, it bends at the slightest pressu-*

re of your hand, it broadens out like a fan, it paints broadly and always goes back to its initial position, always presenting a perfect point". Allow me to add something, with reference to the price, that in watercolor, the paintbrush only caresses the paper, it hardly resists it and so is less damaged. In this way the hairs stay in perfect condition for years.
The thickness -the quantity of bristles- of sable paintbrushes goes from 00 to 14 (00,0,1,2,3..., fig. 74). the number appears on the handle, the length of which, including the ferrule, is about 20 cm, although there are some which are 28 and 29 cm long. Among synthetic paintbrushes are 20 cm palette brushes with shell handles which are bevelled at the end for lifting of white areas, something which some watercolorists do by rubbing the paper with their fingernail.

Fig. 72. A selection of paintbrushes needed for painting in watercolor. Of course this is not obligatory, you can reduce or increase the number, but my experience and that of several watercolorist friends, makes us think that it is a valid selection. From left to right: sable paintbrushes, number 5, number 8 and number 12; a synthetic paintbrush number 8 (here, a variant could be two synthetic brushes numbers 6 and 9); and two broad brushes, one sable number 14 and one synthetic number 18.

Don't forget that natural fur paintbrushes —of sable or of ox— don't resist acids or corrosive liquids. Synthetic fur brushes are the only ones that will allow you to work with bleach or liquid gum.

73

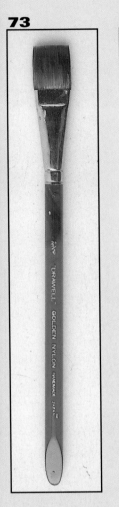

74

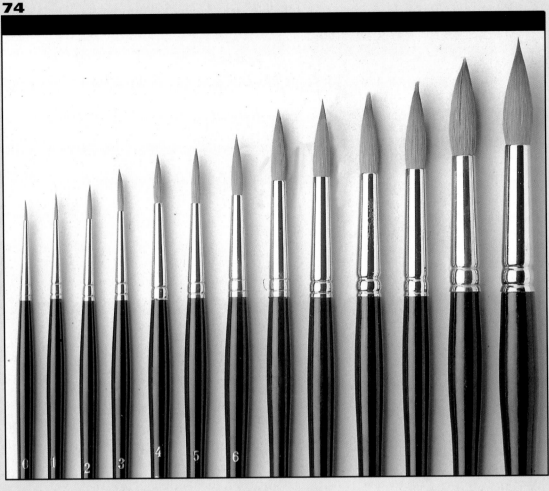

Fig. 73. Special broad brush, number 14, synthetic bristles and with a shell handle, with the end of the handle beveled for opening white lines by scraping the painted area when it is still slightly wet. This is a technique which we will study later on and which many artists achieve using a fingernail.

Fig. 74. A selection of sable paintbrushes, from number 0 to number 14.

Fig. 75. Here are examples of brushes with different kinds of bristles. From left to right: 1 and 2, brushes with rounded, synthetic bristles; 3, broad brush with synthetic bristles; 4, broad brush with sable bristles; 5 and 6, broad brush and rounded paintbrush with ox hair bristles; 7, rounded paintbrush with mongoose fur bristles; 8, Japanese paintbrush with deer hair bristles; 9, rounded *putois* paintbrush with polecat fur bristles; and 10, *petit-gris* broad brush, with squirrel fur bristles.

75

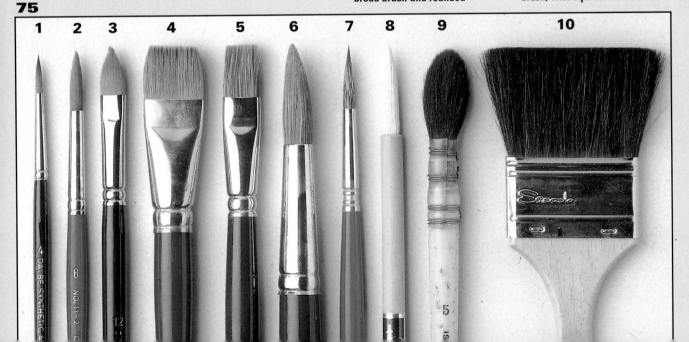

How to Hold the Paintbrush

The most common way of holding a paintbrush to paint in watercolor is the same way as you hold a pencil, though further back on the handle (fig. 76). Holding it near to or further away from the ferrule depends on what you are painting. In the illustrations at the bottom of the page (figs. 78, 79 and 80), you can see three watercolorists holding the paintbrush like a pencil, but while the first and the last hold it far back, almost at the end of the handle, the middle one, to paint some small detail, is holding the paintbrush very near to the ferrule. The other way to hold the paintbrush is with the handle inside the hand (fig. 77): this allows you to paint more fluidly, though with less precision, you need to paint like this when you are painting on a vertical board and painting vertical lines and strokes.

Fig. 76. This is the typical way to hold the paintbrush when watercolor painting: as if it were a pencil, but holding it further back along the handle, and in an almost perpendicular position to the paper.
Fig. 77. This is the other way, less common, with the handle inside your hand and with the brush in a diagonal position to the watercolor you are painting.
Figs. 78, 79, and 80. Here you can see the hands and paintbrushes of three watercolorists painting to show you how each one holds the brush from further down to higher up the handle, depending on the detail they are painting, and depending on the custom and habit of each artist.

76

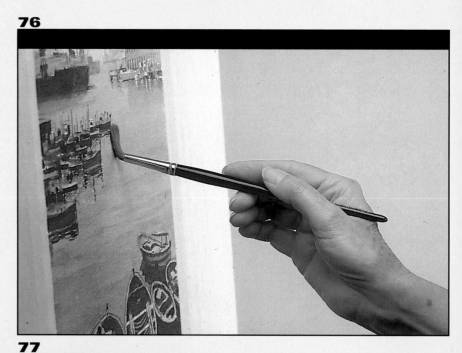

77

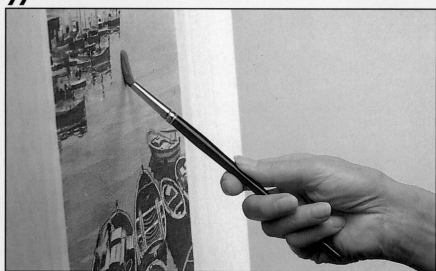

78

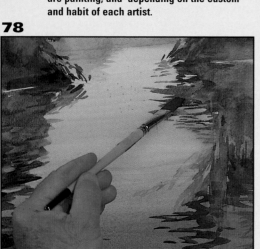

79

80

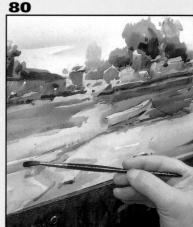

Preserving your Paintbrush

A moment ago, two pages back, we said that watercolor paintbrushes can last for years, this is true, but only if you treat them with a certain amount of care.

When you finish the day's work you must wash the paintbrushes conscientiously: always with water and every now and then with water and soap (fig. 81), gently rubbing the brush over the palm of your hand, without tangling or twisting the bristles, wetting them with plenty of water and then sucking and licking them until the bristles form a good point. Afterwards you have to leave them to dry in a jar with the bristles upwards (fig. 82). Never, NEVER, leave them in a jar with the bristles down if the paintbrushes stay like this for long, and I'm not talking about days, you risk spoiling them for ever. If you take the brushes outside to paint, there are special boxes, like the ones you can see in figure 84. But it is easier and just as efficient to wrap all the paintbrushes together in some cardboard or corrugated paper, held together with an elastic band. The bristles will be protected by the fold of the card held on by sticky tape. You should preserve the paintbrushes by keeping them firmly together.

81

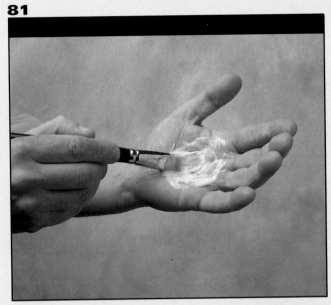

Fig. 81. You must always wet and clean the paintbrushes with clean water when you have finished painting, and from time to time you should wash them with soap and water, as you can see in this picture

84

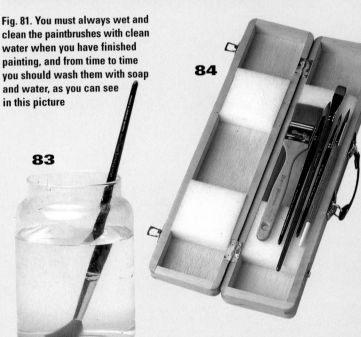

Fig. 82. After you have washed the paintbrushes you must model them with saliva, shaping them with your mouth, sucking them. Afterwards, leave them in a jar with the bristles pointing upwards.

83

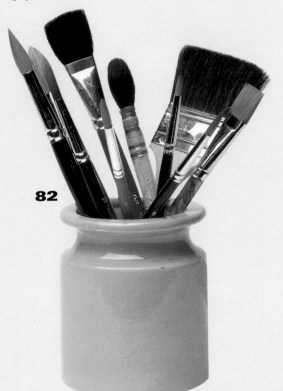

82

Fig. 83. BE CAREFUL, DON'T DO THIS! DO NOT EVER LEAVE THE PAINT-BRUSHES IN THE WATER, not even for a moment. You risk spoiling the bristles and ruining the paintbrush for ever.

Fig. 84. This is a box designed for transporting paintbrushes, guaranteeing that the points of the bristles will not be spoiled. As a home-made and more prosaic solution, you can wrap the brushes in corrugated paper and elastic bands, folding and closing the ends with sticky tape. Anything to avoid exposing the brushes and the ends of the bristles to being damaged because of lack of care.

Equipment for Painting in the Open Air

85

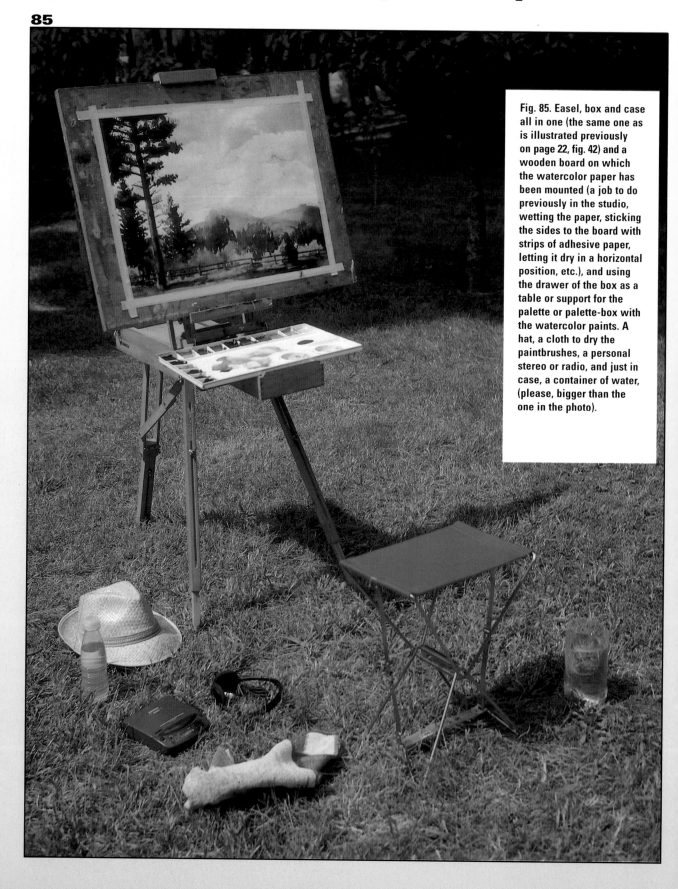

Fig. 85. Easel, box and case all in one (the same one as is illustrated previously on page 22, fig. 42) and a wooden board on which the watercolor paper has been mounted (a job to do previously in the studio, wetting the paper, sticking the sides to the board with strips of adhesive paper, letting it dry in a horizontal position, etc.), and using the drawer of the box as a table or support for the palette or palette-box with the watercolor paints. A hat, a cloth to dry the paintbrushes, a personal stereo or radio, and just in case, a container of water, (please, bigger than the one in the photo).

Equipment for Painting Sketches

If we draw a parallel between a watercolorist and a photographer, we could start by allowing the photographer the studio equipment, the outdoor equipment, and the equipment for taking snapshots, the lastter constituted by a small camera of universal use.

Well, the Winsor & Newton sketching equipment of that you see in figure 86, is the equivalent of the little camera, for taking occasional snap shot photos. A box-palette with eighteen tablets of color and a paintbrush and a flat, plastic container of water, which fits in the leather case. All the equipment can be put in your pocket. This is all you need to fill the sketch block but in color and with water. (As you have seen previously on page 26, fig. 56 this manufacturer produces another model of equipment for painting sketches).

It is true that a painter never stops being a painter, and with equipment like this he can make sketches anytime and anywhere. With this mini-equipment, you can work marvels. The freshness and lightness and the lack of worry in a sketch can sometimes achieve results that a more elaborate picture never could. If one example were be enough to prove this, at the bottom of the page you have three: by **Fresquet**, by **Gaspar Romero** and by **Segú** (figs. 87, 88 and 89).

86

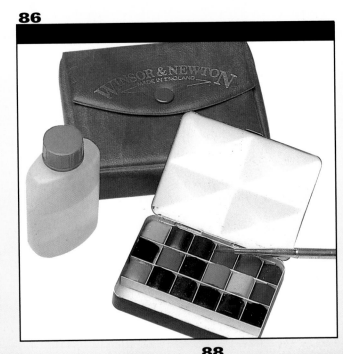

87

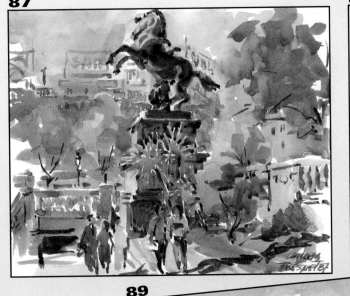

88

Fig. 86 (above). Winsor & Newton equipment for painting studies or sketches in watercolor. It is a miniature set of that which appeared previously on page 26, and which, folded into a leather case, fits in your pocket.

Figs. 87, 88 and 89. Watercolor sketches by the artists Guillem Fresquet, Gaspar Romero and Jordi Segú.

89

Assorted Materials

It is a bit like a sewing basket, however in sewing baskets you sometimes find, next to things you never use, just the thing without which you could not carry on working. Some of these materials and tools are essential, like the files, the boards, the cloths, the sponge, the pencil or the eraser. Others, like the set squares, the clips and the fixer, are not so necessary. In the bazaar which is presented on these double pages (figs. 90 to 105) maybe the best thing to do is to go point by point and explain the specific use of each thing.

90

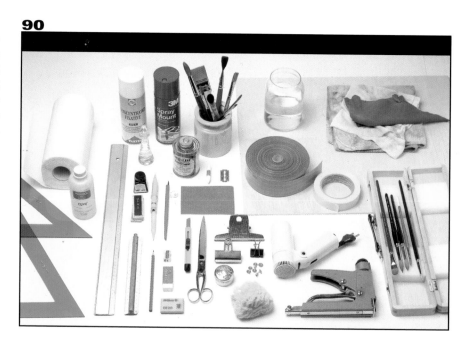

91

Figs. 90 and 91. Above, on the right (fig. 90), a selection of several materials and tools currently in use for watercolor painting. On the left the list begins: Chinese ink in an ink bottle and in a bar, nibs and handles: material needed to produce a technique which we will talk about in the next book.

92

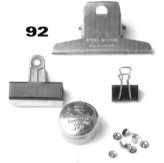

Fig. 92 (left). Clips and drawing pins. Both things are used for holding the paper to the board. The wider clips make it possible to wet the paper with a broad brush, tauten it with your hands and maintain the pressure with these "bulldog" clips. Wait for the paper to dry and then paint.

Fig. 93 (right). Craft knife and scissors. Both of them for cutting; the knife cuts better with the help of a metal ruler; wooden or plastic rulers end up ruined by slips of the knife. This has happened to me.

93

Fig. 94 (right). The pencil sharpener because it is easier and more efficient than sharpening pencils with the knife. The erasers, well, you have to have them but use them as little as possible, so that you don't damage the fibre of the paper. The number 2 or H.B. pencil is for drawing the subjects of the watercolors.

94

95

Fig. 95. Set-squares are not often used by watercolorists, but occasionally they are necessary, so you have to have them.

96

Fig. 96. A double decimeter and a metal ruler. Essential for drawing lines, measuring and cutting paper with the metal ruler and the knife.

97

98

Fig. 97. Adhesive paper in a 4 cm roll and a roll of 3 cm plastic tape. The second is waterproof. For tautening the paper using this material you should stick the paper and then wet it with a palette brush.

Fig. 98. Folders and boards are essential. Folders to keep blank paper and finished watercolors in. Boards, more than one so you can draw and paint. Measuring 55 x 70 cm of 6 mm plywood.

99

Fig. 99. Portable light table, for tracing images or drawings, seeing slides, etc. There are different sizes, they work with batteries or connected to the mains.

101

Fig. 100 (right). A roll of absorbent paper. The famous paper towels! It is used in watercolor to absorb wetness and paint and to remove the remains of water or paint from paintbrushes.

100

102

Fig. 101. Cloths for cleaning paint-brushes and absorbing water or paint. Cotton cloths are good and a towel is fine too. These are essential.

Fig. 103 (below). Rubber glue and spray adhesive to stick papers, and fixative, also in spray for fixing carbon drawings, one of the elements used to do the previous drawing for a watercolor, as we see in a few pages.

Fig. 102 (left). A stick of white chalk, for keeping areas white, sandpaper for lifting off white areas by rubbing, and a razor blade also for lifting off white areas by scraping. We will talk about these methods later on.

104

105

Fig.104. Natural sponge. Plastic sponges exist, but it is better if it is natural, they take more water and are gentle when applied to the paper or when wetting it.

103

Fig. 105. Hair dryer, so that you don't have to wait and can speed up the drying of the paint in a particular part of the watercolor. If there is not one already in your house I recommend that you get one; they are really useful.

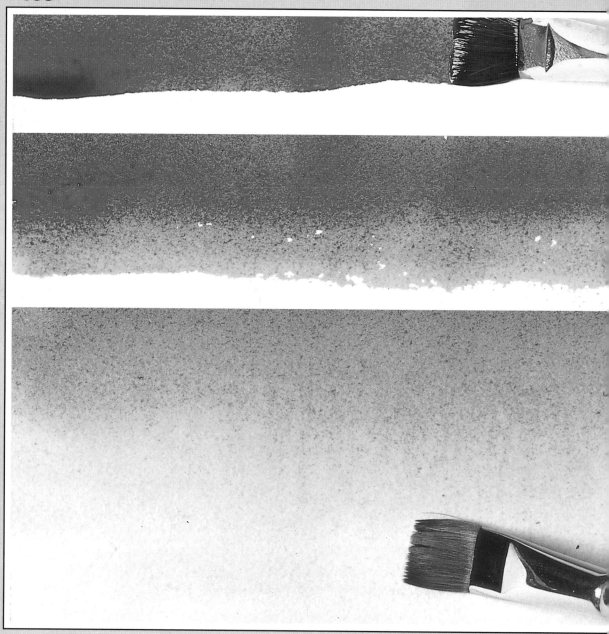

Fig. 106. Painting a gradation forms part of the techniques of watercolor pain-
ting, of which there are many, and a lot more complicated than painting back-
grounds and gradations. However we have to start here to arrive step by step at
more complex techniques, like lifting off white areas with the paintbrush, or
drawing white lines with the beveled end of the brush. We also have to revise
the basics of the art of drawing which is fundamental in painting.

WATERCOLOR TECHNIQUES

The French catholic thinker **Georges Bernanos** wrote: "What you gain in technique you lose in liberty". We have to presume that he was not referring to the technique, or rather techniques, of painting, because if so we can contradict him with what the Japanese printer and painter **Katsushika Hokusai** (1790-1849): "Only when you truly master technique will you cease to be a slave to it and be able to paint as you want to". You have to forget technique. However, before you can forget it you have to learn it. From here on we will talk about lots of techniques, although not all of them. There will be another book in which we will continue studying them. (Until such time as we don't have to worry about technique because we are ignorant about it, we can intrigue ourselves with the inspiration and pleasure of painting).

Introduction to Watercolor Painting Techniques

Lluís Pasqual, the stage director who was among the founders of the Free Theatre of Barcelona, had reached the very top. He was already the director of the Odéon-Théatre de l'Europe, of Paris. That night he was happy. He had achieved, he thought, a great show. Nobody talked about technique, i.e. sound, light, rhythm, timing, entrances, exits.... all this was there of course, but it was not necessary to talk about it: and this is what a success is. **Lluís Pasqual** summed up the idea, saying:

"Technique is like windows, when they are clean you don't notice them".

So that the clean glass of a watercolor

107

108

109

110

passes un-noticed, you are going to learn all the necessary techniques. You will paint gradations on dry and wet on wet. We will talk about the white of the paper, and masking white spaces, about controlling the wetness of the paintbrush, about how necessary it is to always paint from "less to more". We will lift off areas with the bevelled end of the brush or with

a fingernail, with a knife, with sandpaper or with a razor blade; you will draw with a stick of white chalk, you will practise the technique of using a dry paintbrush on rubbed areas, and the textural effects you can create with salt.

These two pages, are like a kind of prologue, they already include two examples of what I have been saying.

Fig. 107. Edward Seago (1910-1974). *Flower market in Hong Kong*. Courtesy of the *David & Charles* editorial, London. A splendid example of Seago's capacity for synthesis, portraying the shapes of the figures, the flowers and the awnings, with just a few brushstrokes.

Figs. 108, 109, 110. Step by step study of a fragment of Seago's watercolor, with the successive coats or glazes, overlaid to portray the subject's shapes and colors.

111

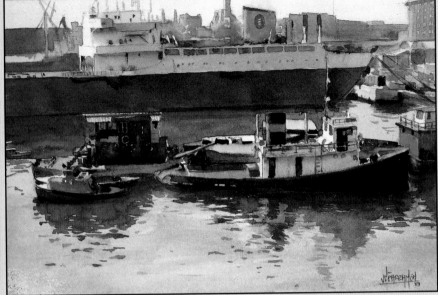

One is by **Edward Seago** (fig. 107 on the opposite page), the great English watercolorist who created a school. The other is one of my seascapes, of the port of Genoa (fig. 111). In both watercolors it is already, even now, possible to see and study technical problems and possible solutions, with the layers of paint and with the reserves of white. I have painted a fraction of **Seago**'s watercolor (figs. 108, 109 and 110) as a foretaste of the study and application of glazes that we are going to do further on in this book. In the seascape you can see the mask made with masking fluid for the mast of the boat in the foreground, note the "cleanness" of this kind of reserve (figs. 113 and 114), though I didn't do this on the

112

113 **114**

original watercolor, I just masked directly by hand (fig. 112), which gives the painting more fluidity, more of a feel of a painting done then and there, which is good for the picture.

But let's not get ahead of our knowledge.

Watercolor painting generally requires, above all, a knowledge of the basics of drawing, applied precisely to watercolor painting. So we are going to start at the beginning, and the beginning is drawing. In brief, but fundamental, it's right there on the next page.

Figs. 111 and 112. José M. Parramón (b. 1919). *Genoa Port*. Artist's collection. Above, the complete watercolor; below, an amplified fragment to show the mast of the boat in the foreground more clearly, and show the results of a mask made with the handheld sideways.

Figs. 113 and 114. The aforementioned mast, masked with liquid gum. The form that must be reserved is first painted with liquid gum (fig. 113). Then the reserve is "passed over", the liquid gum is removed and the reserved form is touched up.

Cézanne's Formula... (and Rubens')

115

According to some, or rather many, XX century painting, especially cubism, has a father: **Paul Cézanne** (fig. 115). Why especially cubism? Because of how he painted, it is clear, especially in the later part of his life. But also because he wrote in a letter to his friend, the painter **Emile Bernard**:

Figs. 115 and 116. Paul Cézanne (1839-1906). *Self-portrait*, Museum of Orsay, Paris.

> **"In nature everything is made up of three basic shapes: the cube, the cylinder and the sphere".**

And this is what **Cézanne** did. However, two centuries earlier, the Flemish painter **Rubens** (fig. 117)

117

wrote in his book *Dealing with the human figure*:

> **"The basic structure of the human figure can be reduced to a cube, a cylinder and a triangle".**

Rubens affirmed that the human figure can be seen in this way, and **Cézanne** widened this to include everything. If you can reduce everything to elemental geometrical figures —a cube, a cylinder, a sphere (fig. 116)—, then you can already draw everything that reality can offer, from your own hand, to the whole city, or the field you can see from a window of your house.

So, do it. With this you will start to sort everything out, all the problems of drawing: perspective (fig. 118), proportions, light and shade, contrast. When you think that you know how to draw cubes, cylinders and spheres, capture reality in these forms. You'll see, its great!

Fig. 117. Rubens (1577-1640). *Self-portrait*. Anversa, Rubenshuis.

116

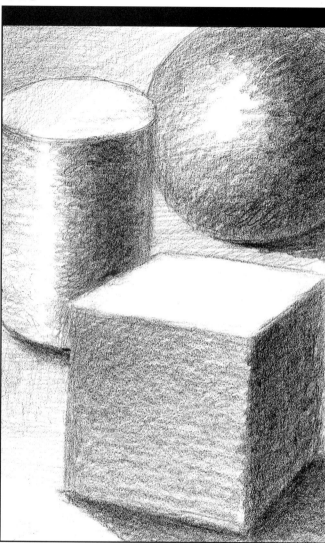

118

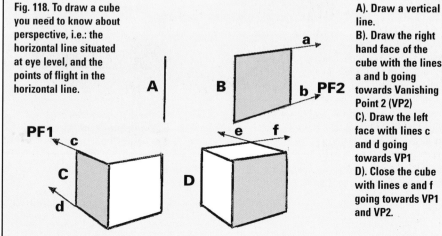

Fig. 118. To draw a cube you need to know about perspective, i.e.: the horizontal line situated at eye level, and the points of flight in the horizontal line.

A). Draw a vertical line.
B). Draw the right hand face of the cube with the lines a and b going towards Vanishing Point 2 (VP2)
C). Draw the left face with lines c and d going towards VP1
D). Close the cube with lines e and f going towards VP1 and VP2.

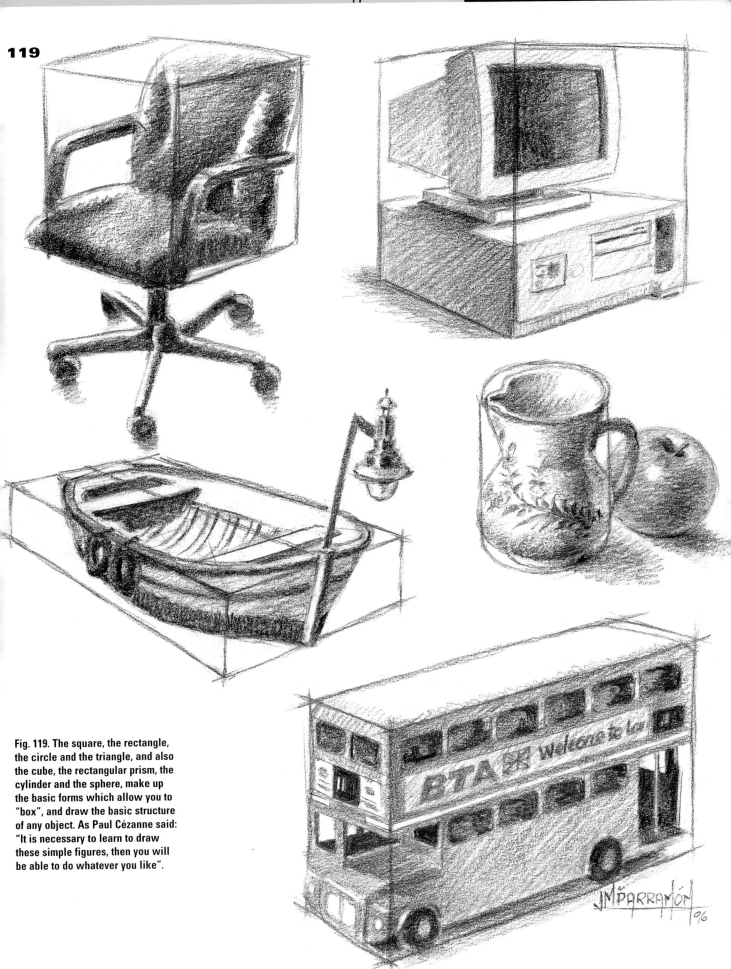

119

Fig. 119. The square, the rectangle, the circle and the triangle, and also the cube, the rectangular prism, the cylinder and the sphere, make up the basic forms which allow you to "box", and draw the basic structure of any object. As Paul Cézanne said: "It is necessary to learn to draw these simple figures, then you will be able to do whatever you like".

"Boxing", Dimensions and Counter-mold

The hand draws, it paints. However, before, immediately before —at times it seems to be done simultaneously—, the eye has seen. You can't draw if you don't know how to SEE. The famous North American portrait painter and watercolorist **Sargent**, was quite right when he said that you always had to cultivate your "powers of observation". To know how to observe, basically to know how to look, is essentially knowing how to calculate and to compare dimensions and proportions. This is how you calculate the dimensions of everything, or each part of a thing, through this comparison between one measurement and others, between one form and others. It can be called "boxing" (fig. 121). It is, in a way, as if we were fitting reality into boxes (remember **Cézanne** and **Rubens**) and we transfer reality, in these boxes, to our drawing.

It is all about relating the width with the height, looking for horizontal and vertical reference points to situate the forms and relate them to each other (fig. 122). Or comparing the "empty" with the "full" within the boxes: this is called counter-mold or *contramolde* ("against the mold"), (fig. 123).

120

Fig.120. This is the subject. A small vase and some flowers. We want to draw them bearing in mind the following process.

Fig. 121. First the "boxing". Study the subject, mentally calculating the maximum width and height, you have to "box" the subject within a cube, a cylinder, a rectangular cube or a sphere, just as we saw on the previous page, or rather in a square, a rectangle, etc. (The plan of the vase and the roses is identical to the subject, with a slight change to the leaf in the foreground).

Fig. 122. The second step, still without drawing, consists of calculating dimensions and proportions, noting measurements which are repeated or coincide, like in the vertical and the diagonal (A-A and B-B) red lines on the jar and roses. Notice that in this and in all subjects, there are points of reference which determine the position of the parts of the subject, which coincide in a vertical or horizontal sense (red points and blue lines).

Fig. 123. Lastly, you have to study the *contramolde*; i.e., the forms determined by the empty spaces within and around the subject. When the box has been made (fig. 121), and the dimensions which are repeated and points which relate some forms with others, have been checked (fig.122), and the *contramolde* has been studied and structured, then you can start to draw, first with faint lines which will allow you to work and draw with perfect security in the end.

121

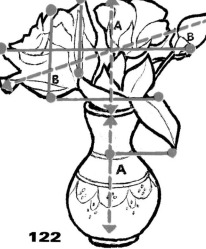

122

123

Alla Prima Drawing

Alla prima which translates "at the first" i.e. without thinking about it or preparing, drawing "free hand" everything you can see which is on top of your work table: the tape holder, the jar of paintbrushes, the jar of water, the palette-box or the palette, etc., and your hand itself which is the thing which is most, if you'll pardon the pun, at hand. Not the hand which is drawing but the other one.

It is about drawing the first thing that comes to hand. With a fine point rotary pen, or a black ball-point pen, it's about tracing lines, drawing these things and your hand in different positions. Tracing simply one line,

without highlights or shading and without depth. Until we start discovering, little by little, look by look, line by line, what the basic forms are, the key details in each subject (fig. 124).

124

Fig. 124. Drawing "freehand", without boxing or sketching, drawing directly, with a ball-point pen or a fine rotary pen, without shading, with just lines, as if you were drawing in order to paint a watercolor. Drawing, as I say, what you see right now on your work table, the tapeholder, the jar of brushes, the jar of water, some books... or ,go and find small objects, jugs, plates, glasses, fruit. Also draw your left hand, or if you are left-handed, your right one. Start with things with less complicated shapes and end up by drawing your own hand. This will be good practice for the drawing exercise which I propose on the next page.

Doing a Line Drawing Like This

126

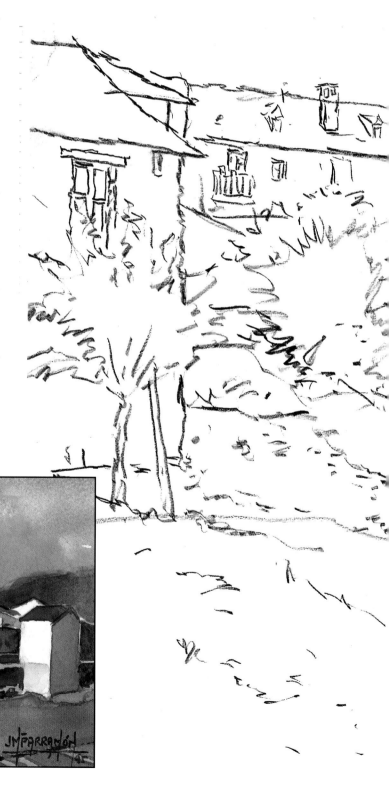

I was in the village Tirvia, in the Pyrenees, near the Spanish border with France; a fantastic place because of the number of things there are to paint. I painted several oil and watercolor paintings inside and outside the village, among them, a watercolor sketch seeing the village from a meadow which is in the foreground of the picture. However, before painting this watercolor (you can see it in fig. 125) I thought it would be good to do a line drawing of the subject, so that I could maybe publish it in one of my books as an exercise in lineal drawing.

Well, the chance to do just that has arrived, we are now not drawing small or medium sized subjects, but rather wider subjects, like a room in your house, your place of work, your studio... or the houses and roofs and terraces that you can see from your own home... or a landscape, a seascape, a place you know and have seen.

A subject which allows you to practise, while drawing naturally, the mental calculations of dimensions and proportions with the help of a pencil or a paintbrush as a mediating element —a subject we are going to deal with in four pages time—. This is an exercise in drawing naturally with the point of a lead pencil, without shading, with only lines, just as you draw a picture you are going to paint in watercolor. Remembering that the play of light and shadow will have to be achieved with the paint and the colors, and remembering that watercolor is transparent and so if you draw shadows with pencil, they will be seen through the watercolors, dirtying them and spoiling the transparent and chromatic quality of the picture.

125

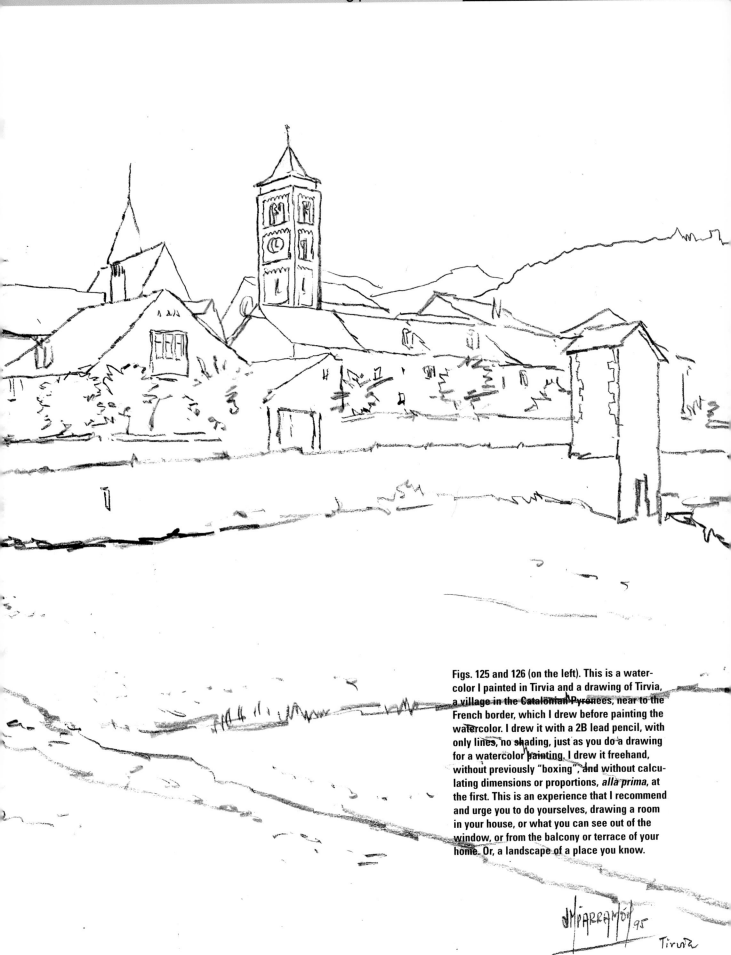

Figs. 125 and 126 (on the left). This is a water-color I painted in Tirvia and a drawing of Tirvia, a village in the Catalonian Pyronees, near to the French border, which I drew before painting the watercolor. I drew it with a 2B lead pencil, with only lines, no shading, just as you do a drawing for a watercolor painting. I drew it freehand, without previously "boxing", and without calcu-lating dimensions or proportions, *alla prima*, at the first. This is an experience that I recommend and urge you to do yourselves, drawing a room in your house, or what you can see out of the window, or from the balcony or terrace of your home. Or, a landscape of a place you know.

Tirvia

How to Start a Watercolor

127

128

129

130

Ticiano, from Venice, didn't draw his pictures beforehand. He even laughed at those who did, saying: *"In Florence they draw a lot, but they don't know how to paint. You can't have forms before color. Forms are marks of color, they come out while you are painting".*

Completely in contrary to this is a sentence by **Ingres:** *"Painting is the servant of drawing".*

My advice is that, as a watercolorist, you stay for the moment with **Ingres**. Mainly because (you can never reiterate these essential characteristics too much), *watercolor doesn't cover, so you must always go from less to more.* Some *light* errors can be remedied by painting over them in a darker color. However, *dark* errors, in watercolor, can't be remedied with a brushstroke of lighter color.

So, although there is the odd exceptional case of a watercolorist who doesn't draw previously, (it seems that at times **Turner** was one of these), the vast majority do. Even **Fortuny** drew, although only a little.

There isn't really a rule about drawing previously; some draw in great detail, with as much precision as the study which occupies the previous double page, whereas others just use four guiding lines. In any case, for almost all watercolorists starting a watercolor means starting drawing.

This being so, one can sit in front of the real thing, the subject itself, and start sketching. Or you can do this from some notes or a photo, but this is not the same.

Rennaiscence or Neo-classic painters usually painted in their workshops. The impressionists went out into the countryside to allow themselves to be *impressed* by nature. The contempo-

Figs. 127 and 128. Some, though not many, watercolorists don't draw their subject before they start painting. The most typical is to draw the subject with a lead pencil. With a 2B pencil or harder so that the graphite doesn't dirty the picture when it becomes diluted with water.

Figs. 129 and 130. But not all watercolorists draw with lead pencil, Vicenç Ballestar draws, though very lightly, with carbon, which he half rubs out with a cloth before he starts painting.

rary Hyper-realist **Antonio López** does the same, even if what he is looking at is an old broken sink, or a deserted corner on Madrid's Gran Vía: *"There are painters who have everything in their mind. Not me, I*

have always needed the help of reality".

From the practical point of view, the tool with which you do the initial drawing is the least important thing. Use what you are most comfortable with, with which you feel safest: lead pencil, or charcoal, like the watercolorist **Ballester** (figs. 127 to 130), a black or blue ball-point pen like **Julio Quesada** (figs. 131 and 132), who also uses color crayons and pencils; or a thin paint brush, with very light watercolor, like the artist **Gaspar Romero** (figs. 133 and 134).

131

Figs. 131 and 132. Julio Quesada draws his watercolors with what he has handy; blue and black ball-point pen, blue or sepia wax crayon, blue, sepia and red colored pencils. "It depends, in a way, on the subject, and on the harmonization of colors it offers", he says.

132

133

134

Figs. 133 and 134. The watercolorist Gaspar Romero generally draws in pencil and on occasions directly with a bar of Chinese ink. However I have also seen him draw directly with a thin sable paintbrush and very liquid watercolor paint, in a light color, which harmonizes with the color range of the subject of the painting: light blue if the subject has a cold range of colors; ochre, very diluted with water if the subject offers a range of warm colors.

Dürer's Grid

135

Dürer's famous grid (fig. 135) is the elemental mechanism to the service of art. Or, to put it in another way, it is a practical application of "divide and conquer". Or, it is an analytical method of *quartering* reality (to quarter is to cut into four pieces). **Dürer** put a glass grid between himself and, in this case, the model he wanted to draw. For example, you can put this grid in front of a subject like this still life in figure 136. Then draw the same grid on your watercolor paper, making it larger, or reducing it according to the size of the paper, and then paint the watercolor, *first rubbing out the lines of the grid* (figs. 137 and 138). The grid divides reality into portions, and it is easier to reproduce something with precision in pieces than as a whole. What's more, the grid indicates with its horizontal and vertical lines where everything is, (half way up the third vertical, at the start of the fourth horizontal...) and what exact size each element is (one and a half squares high, two squares wide).

All this allows us to work out the relation between different parts of the drawing.

136

Figs. 136, 137 and 138. Imitating Dürer's idea, if you put a gridded piece of cardboard behind a still life, and choose quite a low view point (fig. 136), you can draw the subject more easily, working with the same grid reduced or enlarged on your watercolor paper (fig. 137). Of course, you should rub out the grid before painting the watercolor (fig. 138).

137

138

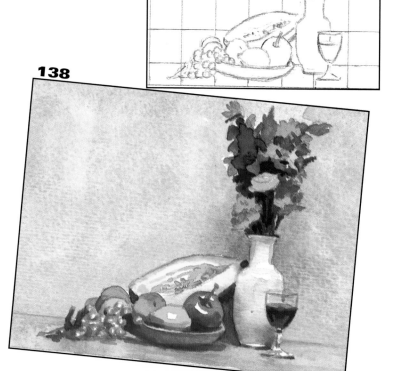

The Cross as the Synthesis of the Grid

The grid can however be simplified or synthesised by being reduced to a cross. We have already seen that to grid is to quarter something, i.e. *divide it into four*. This is what a cross drawn on the surface of the paper does: it divides it into four parts. Everything I have said about the grid can be applied to the cross which is its synthesis. This cross, imaginary on the subject and real on the paper, divides reality into four squares, which converge in the center, and each has a vertical and a horizontal tangent (figs. 139 to 143).

When I draw or paint from life, whether it is a still life, an interior, a seascape or a landscape, I always start by dividing the picture with a cross like that in figure 139. From this cross, for me, begins the calculating of dimensions and proportions, imagining this cross on the subject, and trying to find a body, a limit, a corner, something whose position corresponds to the horizontal or the vertical axis of the cross. Sometimes it is only a question of slightly altering the squares, imagining something a little more to the left, or to the right, or further up or down, so that this body, this edge, etc., is just on the center of the vertical or horizontal coinciding with the cross. However, let's talk about it with images and examples, as we see on the following pages 56 and 57 the practical application of this technique.

139

141

140

142

143

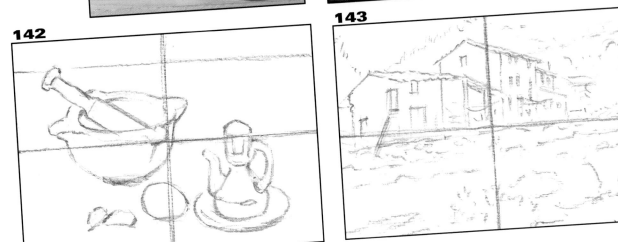

Figs. 139 to 143. By drawing a cross on your watercolor paper, before beginning to draw, you will be "gridding the subject in synthesis". You then have to imagine this same cross on the model, so that you can calculate and more easily see the way parts of the model coincide with the vertical and horizontal line of the cross which you have drawn on the paper, knowing that this coincidence is always there, or can always be found, whatever the subject of the painting. Try it and you will see.

Pencil or Paintbrush as a Measuring Instrument

The landscape we are going to draw, and afterwards paint in watercolor, is that which you can see in the adjacent image (fig. 144): a village —Carboneras, in the Spanish province of Cuenca— with its church on a hill, a field with a little house, a few more houses, some shrubs... and we are going to draw with charcoal, which rubs out easily with a malleable eraser, or with a cloth.

Figure 145. First, look carefully as long as you need, to mentally calculating dimensions and proportions. Next draw the cross. The first discovery is that the left vertical of the church coincides with the vertical line of the cross. From here the roof, which I draw by 'feeling'. Check that the church, from the corner in the center, to the top of the belfry, takes up $1/4$ of the width of the upper right-hand square of the paper. The highest point of the belfry (A) is halfway (a'-a) between the top of the paper, and the horizontal axis of the cross.

Figure 146. When I compare, I see that from the center of the belfry (D) to the vertical of the cross (E) there is the same distance as from there to the left-hand edge of the church (F). Also, this distance (b'-b') is the same from there to the edge of the vegetation next to the church (G), and again b'. And so the central structure is done.

Figure 147. Incidentally, remember that all these calculations are the result of measuring, and comparing different parts using the old system of pencil or paintbrush and extended arm.

144

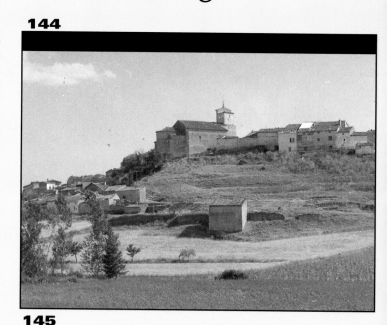

145

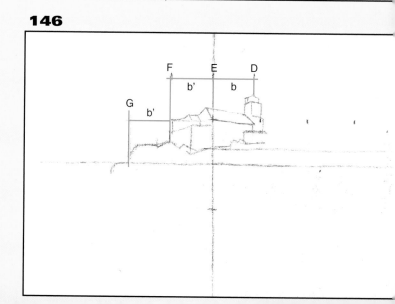

147

148

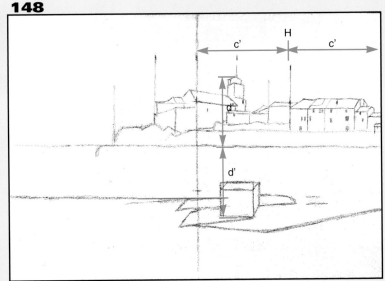

Figure 148. Now the ridge of houses on the right hand side. Measuring with the pencil I discover that the left hand corner of the house in the center (H) coincides with c'-c', i.e. more or less with half the distance of the vertical of the cross and the right-hand edge of the picture. From here I draw the rest of the houses by eye. So let's look at the cubic construction of the foreground. Thanks to my measuring pencil I discover that the distance d' (from the vertical of the bell tower to the horizontal of the cross) is almost equal to d' (from here to the base of the cubicle). I draw it. Half way up the vertical of the cube I draw a horizontal line which goes to the bases of the houses in the left-hand bottom half of the picture.

Figure 149. I look for the center of these houses. By eye I find their right-hand edge (J). I divide from here to the edge of the painting (e'-e') and I see that the center is the left-hand edge (K) of the house in the middle. I draw it and from here on start constructing the group of roofs and facades. To tell you the truth, it is much more difficult to explain it than it is to do it. When you are doing it your mental autopilot starts working, that tacit agreement between mind and hand. the calculations do themselves, more by intuition than you being aware of each step.

Figure 150. From here on doing the rest of the drawing is easy.

149

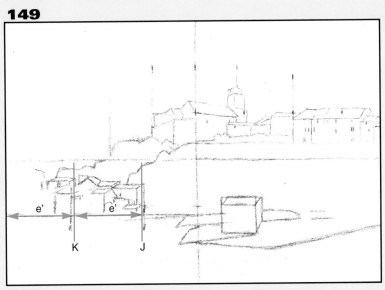

150

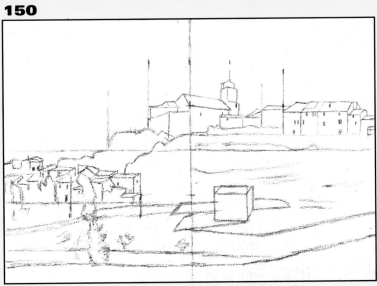

Modelling and Shading

151

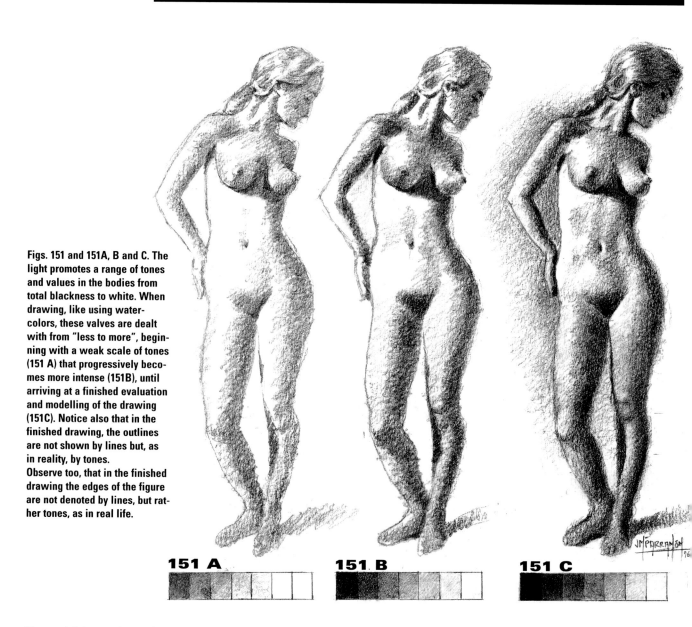

Figs. 151 and 151A, B and C. The light promotes a range of tones and values in the bodies from total blackness to white. When drawing, like using watercolors, these valves are dealt with from "less to more", beginning with a weak scale of tones (151 A) that progressively becomes more intense (151B), until arriving at a finished evaluation and modelling of the drawing (151C). Notice also that in the finished drawing, the outlines are not shown by lines but, as in reality, by tones.
Observe too, that in the finished drawing the edges of the figure are not denoted by lines, but rather tones, as in real life.

151 A

151 B

151 C

To model is to give volume through shading, that is to say, the shades, which are tones, on a scale going from black to white. However, let's talk a little first about sculpture, which is the artistic form of "really" expressing volume, not just "figuratively".
Michael Angelo said: *"To sculpt is to take away from a block of marble what is not needed"*. This is sculpture by subtraction, a little like the *contra-molde* of page 48. We can see the model on this page better, because we have filled the empty space that surrounds her with blue. However, there is another form of sculpture: that of addition. In the old schools of art, in the first year they only studied artistic drawing and modelling. Nothing more. This means that on the one hand they copied lots of plaster using charcoal; on the other, they modelled, with clay, using their hands. In both cases, one flat on paper the other with volume in clay, the forms were appreciated. It was a double exercise which was very useful to confirm the doctrine of **Tiziano**, that things in reality are not drawn because they don't have lines to limit them.

152

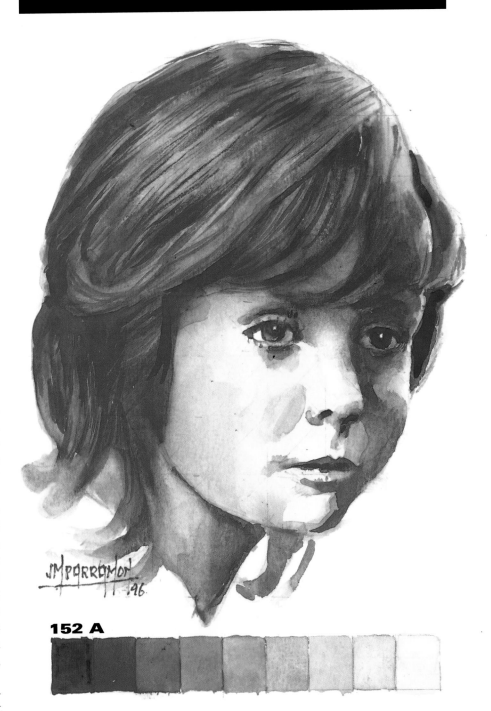

J.M PARRAMON '96

152 A

Shapes are marks, made up of lighter and darker tones. So shading is not just seeing what to shade, but which tone each part of the model we are drawing has in reality.

Shading is comparing.

This says it all. Nothing more than half-closing your eyes according to the old formula, and looking. Look at the model with your eyes half-closed and your eyelids slightly tense. By seeing everything a little more darkly, we can see what we need to more clearly. Bodies loose definition, details become diluted and contrasts stand out more. From a strict realism point of view, we can say that depths exist for themselves. This is what sculpture gives. But someone drawing only has a flat surface available. Their shapes, like those of a cinematographer, come from the light. White is total light, black is an absence of light. Between one and the other, there an infinite variety of intermediate grays. It is these which allow us to mould the model until we reach the state of C in figure 151, where the edges of the figure are already marked, with a gentle gray background rather than with a line. Remember the basic law of watercolor? ALWAYS GO FROM LESS TO MORE. Well, the same applies to modelling with a lead pencil or charcoal. From less to more and all at the same time. Don"t first finish the head and then start on the body, like an amateur. So, go from less to more and all at once, as you can see in these successive stage figures (151A, B and C)

But now, although we will never really stop drawing, we are going to act as if we have. From the next page we will start the techniques of watercolor. Let's say it with big black letters:

YOUR ATTENTION PLEASE: WE ARE NOW GOING TO PAINT!

But before we turn the page, we still have to see how everything we have said about shading and modelling is applied perfectly to the face in the adjoining figure 152, a monochromatic blue watercolor. The same scale of shades, the same progression from less to more... but with blue watercolor instead of black lead pencil.

Figs. 152 and 152A. If there is a play of light and shadow, then there is modelling and shading, in drawing and in painting. Painting in watercolor you also have to check the tonal value of some colors in comparison with others again and again, to achieve good modelling.

Painting a Uniform Background on Dry

153

Fig. 153. Time to work! You should work with thick rough grain paper, on which you are going draw in pencil a 15 x 15 cm box. Prepare a certain amount of green, or ultra marineblue water-color, also have at hand a scrap of the same quality paper to test the colour. Slightly incline the board so that the watercolor paint runs downwards, but not too much. Now we are ready, using a number 18 palette brush, to paint the upper part of the box, a strip of about 2 or 3 cm, from side to side.

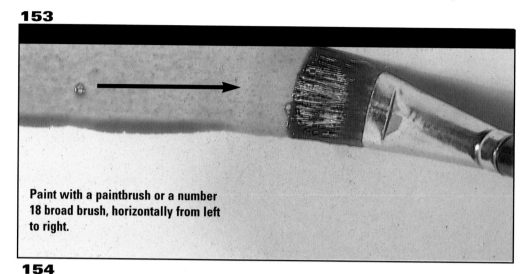

Paint with a paintbrush or a number 18 broad brush, horizontally from left to right.

154

Fig. 154. Work quickly, so that you don't lose the moistness. Make the wash run downwards, now using vertical brush strokes, keeping the paint at the bottom limit. Keep on inclining the board more or less, so that the accumulated liquid paint goes further down or stops as you require from one moment to the next.

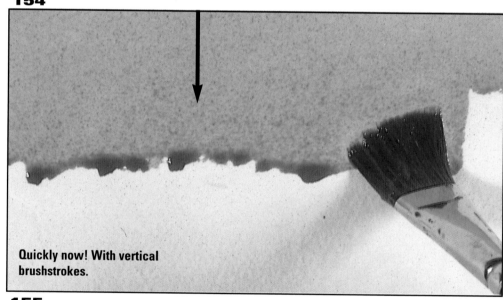

Quickly now! With vertical brushstrokes.

155

Fig. 155. If all has gone well, when you reach the bottom edge of the box, there will still be a little accumulated watercolor left over. Quickly dry the paintbrush with a rag and with it suck up the paint at the base of the box, until you achieve a uniform result. The end result depends, firstly, on the quality of the paper; secondly, on inclining the board more or less, and, finally, on how much paint there was on the paintbrush. You have to remember that retouching is impossible. If it comes out badly, start again, until it comes out right.

Controlling the Moistness of the Paintbrush

Now you have to know how to darken, how to empty the brush, of just water and of water and paint. You need to know how to absorb or suck up paint, to reabsorb when you want lift off white areas, to reduce or remove paint...

One of the most common methods of emptying a paintbrush is to squeeze the bristles with a cloth (fig. 156); another method which is also used is to drain the brush by squeezing it between the thumb and forefinger, as **Pepe Martínez Lozano** does, dirtying his fingers and letting the liquid which comes out of the brush fall into a small bucket which is what he uses to hold water. (fig. 157). A variation on the rag with the advantage of being to "use and throw away", is paper towel (fig. 158). Lastly, let me tell you about the "wild dusting" of watercolorist **Ceferino Olivé**, who beats the paintbrush against the floor, slapping it energetically (fig. 159).

156

ATTENTION! The three figures on the previous page and all the techniques of watercolor painting that appear in this book, need to be put into practice, to actually be done... in order to learn how to really DO them. Please don't stop doing this.

157

Fig. 156. You can empty a paintbrush of water, or paint, with a cotton cloth, or a towel, pinching the bristles and more or less draining it.

Fig. 157. Still more simple, without a cloth or anything. Using your fingers, pinching the bristles with your thumb and forefinger, and so squeezing out the water and paint from the brush, letting the drips fall into your water container, or a small bucket hanging at medium height, as the artist Martínez Lozano does.

158

159

Fig. 158. Paper towel can perform the same function, but it is not as efficient as a towel cloth.

Fig. 159. Finally, you can also beat the brush against the floor with energetic slaps, to get rid of the water and paint. Ceferino Olivé, who uses this method, covers the floor with paper.

Painting a Gradation on Dry

160

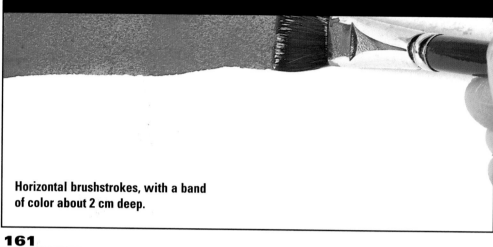

Horizontal brushstrokes, with a band of color about 2 cm deep.

Fig. 160. Again, draw a box of more or less 15 x 15 cm. But now you are going to paint a red degrading on dry, using a number 18 broad brush. Do you have your paper for tests at hand? This time, success depends on the amount of water the brush is carrying when you start to gradate. Let's start at the beginning. First paint a strip of color, in a horizontal direction, in the top part of the frame.

161

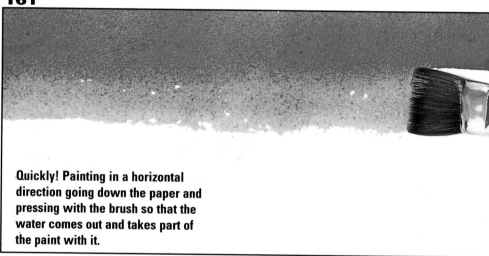

Quickly! Painting in a horizontal direction going down the paper and pressing with the brush so that the water comes out and takes part of the paint with it.

Fig. 161. Quickly wash the brush, drain it a little on the edge of the water jar and apply the brush on the strip you have painted on its bottom half. From there down you start to gradate, the brush, with the water it is carrying, takes part of the watercolor from the top down to the bottom. Part, but not all of it, this is the gradation.

162

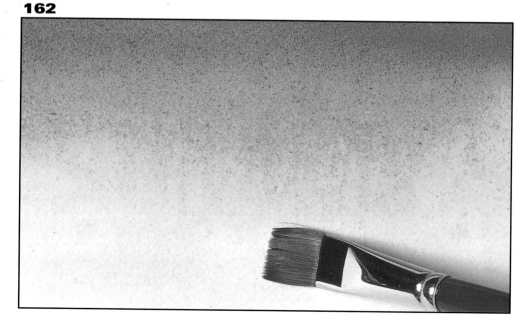

Fig. 162. Wash the brush again, drain it and carry on degrading. Fill and empty the brush, controlling the amount of liquid it is holding, go back, retouch... but without overdoing it. If you go backwards towards the upper part of the gradation, you can cause marks. Try to work quickly but calmly. It seems a contradiction, but you understand me, don't you?

Gradation on Wet

163

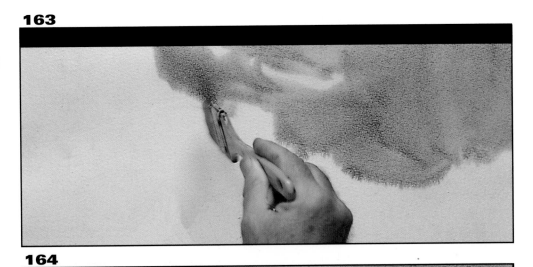

Fig. 163. Now try to paint, rain on wet, a sky which is threatening rain. Do this with a number 12 paintbrush (you could also use a number 18 or number 20 broad brush), Draw a box of 20 x 10 cm. You are going to paint the sky with Payne gray and a little ultramarine blue. Start by wetting the whole space with clean water; wait for the wetness to diminish and when it is not really wet, just slightly damp, paint the upper mark with Payne gray.

164

Figs. 164 and 165. Keep spreading the paint towards the left, draining the brush with a cloth, and applying it on the wet paper sometimes with more and sometimes less paint, whatever you like! There is no rule or formula to follow. It is a question of trying, maybe adding paint, or maybe taking it away, wetting it, absorbing it and painting marks, shapes, and so on.

165

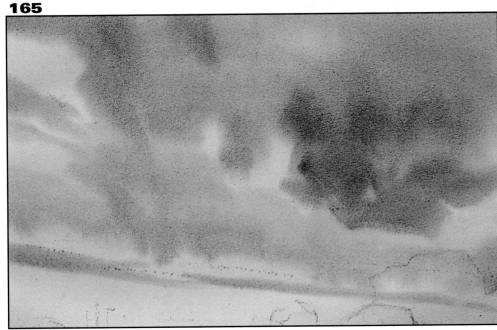

Painting Cubes with Different Tones

166

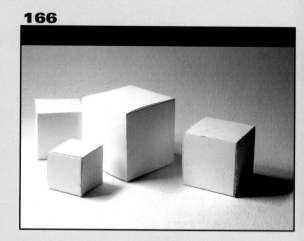

We have made a model of four different sized cubes, lit from the side, as you can see in the adjacent photo (fig. 166). The sizes of the cubes are as follows (from left to right): 47 mm, 35 mm, 65 mm and 50 mm. There is a sheet of white cardboard, curved backwards, as a background, and the arrangement is lit by an anglepoise lamp or something similar.

So, now that is ready we can begin. Start by mounting the paper, 30 x 18 cm, on the board with sticky tape, and drawing the arrangement with an HB lead pencil or an ordinary no. 2 pencil. Now start to paint, with just one color: Payne gray. First, paint all the background with a very, very light gray, and with lots of water, keeping the shapes of the cubes white. While this first wash is still damp, paint the darker tone in the background, starting in the upper right-hand corner (fig. 167). Don't stop. Keep going. Spread this deep gray towards the left-hand side; work quickly, gradating the gray, squeezing the paint out of the paintbrush if necessary. Don't worry if you haven't achieved the depth you are after; you can retouch the background with a darker gray, when this first coat is dry. That is what I had to do. When the background has dried completely, paint the front faces of the cubes keeping the upper faces white, but not the sides which are in the shade. This is how I did it (fig.168). Bear in mind that the intensity of each face is different. The front face of the largest cube is darker on the bottom right-hand corner. When the front faces have dried, paint the faces which are in the shade, starting with the cube on the right, the darkest, but without painting the projected shadows yet. Wait until the shades are dry and then paint the shadows the cubes cast, starting with the one on the right, with the gradation that you can see in the model.

167

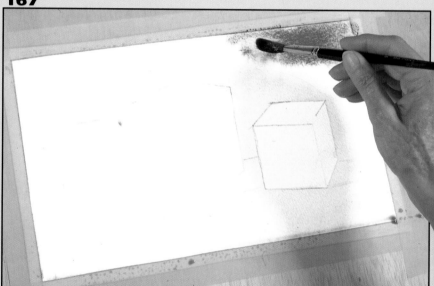

168

Figs. 166 and 167. Above, the arrangement, with the four different sized cubes. Below, after wetting the background with a wash of very light Payne gray, apply a deep layer of the same Payne gray in the top right hand part of the paper, starting the gradation which you can see on the model.

At some point, don't forget to paint a very light wash on the upper face of the cube on the right and to do the lines of the bases of the cubes (fig. 169).

Finally, consider the possibility of retouching some of the profiles of the illuminated parts with a knife, and with a pencil, some places where paint is missing at the edges of the shadows. This is what I did before I decided that the exercise was finished (fig. 170).

Fig. 168. When the background gradation is dry, paint the front faces of the cubes, and then the lateral faces, with the same tone.

Fig. 169. Paint the shading on the cubes themselves, bearing in mind the different tones: practically black on the face of the cube on the right. The largest and smallest cubes are of similar tones. Also, remember the gradations on these faces.

Fig. 170. This is the final result of a very interesting exercise from a technical point of view, without the worry of dealing with color, using only Payne gray, achieving different tones in small uniform areas, and with slight gradations.

169

170

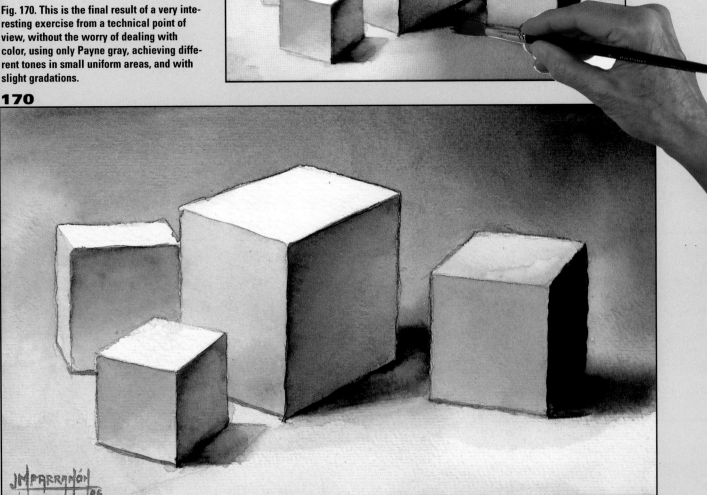

Painting Gradations on Cylinders

171

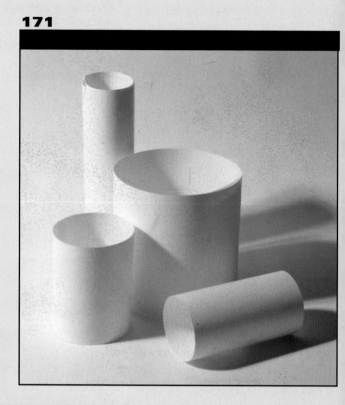

Here is an interesting exercise to practise painting gradations as they apply to some cylinders, four cylinders of different heights and diameters, which you can easily make by cutting, rolling and sticking white cardboard. Put the cylinders against a background of white cardboard curved backwards, as you can see in the arrangement in figure 171. Paint using Payne gray and a rounded, number 9 or 10, sable paintbrush, on watercolor paper, in a frame of 18 x 20 cm (this is the size I worked with). Everything ready? Right, draw the subject with an HB or 2B pencil within the box you can see in figure 178 of the finished watercolor. With a wide brush, wet the paper to eliminate possible traces of grease. Wait for this to dry and then paint a wash of light gray, very light, regular and uniform, all over the background of the arrangement, to outline, and make white edges for the lit edges of the two cylinders on the left. Accentuate the tone of the outline of these two cylinders; not a lot, just enough to make them contrast more with the background (fig. 172).

Afterwards, paint the shadows of the circles, on the widest cylinder in the middle and the one in the foreground on the left. (fig. 173). First paint the circular shape with its edge on the diagonal, with quite a deep tone, and before

it is dry, with a clean and half squeezed out paintbrush, do the gradation of the upper part, as I am doing it in the aforementioned figure 173.

Do the same with the circle of the cylinder which is in a horizontal position in the foreground. Do the first gradation, starting with a strip of deep Payne gray in the middle of the cylinder, and quickly clean the paintbrush with water and squeeze out almost all the water and apply it wet on the upper edge of the strip you painted before, painting as I am in figure 174 on page 66. Don't stop! Without

172

Fig. 172. Once I had drawn the arrangement, I painted a wash of light gray over all the background, accentuating the tone on the profile of both cylinders on the left, in order to make the edges stand out against the background.

173

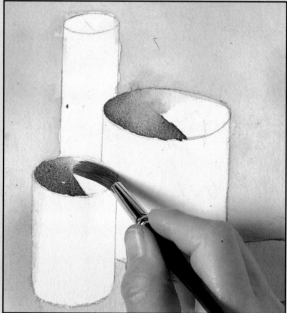

Fig. 173. Afterwards, I painted the shadows inside the circles of both cylinders, the wider one and the one in the left-hand foreground. I painted the circular shape with a diagonal going towards the right, gradating the upper limit while it was still wet.

Fig. 174. Next, I painted the circular shading of the horizontal cylinder in the foreground, and its shadow, and the gradation of the upper and underneath part, the later being of reflected light.

174

175

176

177

cleaning the paintbrush do the same with the gradation of the underneath part, which shows the reflected light. Do the same to the narrower, taller cylinder in the background (fig. 175). And that's is. You must apply the same techniques for all the gradations and the shadows projected towards the right, on the paper background. First, the strip of deep gray paint, afterwards clean and squeeze the paintbrush, gradate, add or remove paint and that is all.

Figures 176 and 177 show us the possibility of correcting little imperfections. opening and scraping with the knife, or outlining with a pencil.

178

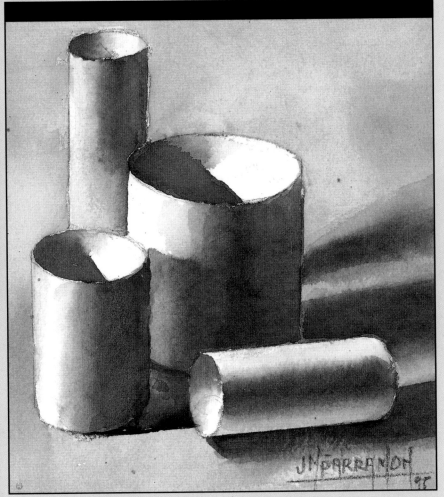

Fig. 175 (above on the left). The painting of the shadows in the circles and the gradation on the narrow cylinder in the background, with that reflection on the bottom part, caused by the wider cylinder in the center.

Figs. 176, 177 and 178. I finished the exercise by painting the effects of light and shade on the wider cylinder in the center, and the projected shadows of the arrangement on the floor, always with the same method of first painting the strip and after doing the gradation of the edges. Lastly, as a general finishing touch, I used the knife for scraping and erasing small errors (fig. 176), and with the lead pencil (number 2 or HB) I hid little gaps without paint.

179

Fig. 179. During the process of this exercise and the former one, about tones in cubes, I always had a scrap of paper at hand, on which I tried the various shades of gray, before painting them on the definitive watercolor picture.

Always from Less to More

If you paint in oil, you will already know that it is possible to paint light on dark because oil paint, like acrylic, gouache, and even pastels, are opaque, and paints which cover: they allow you to paint with pure white on absolute black. This means with these mediums, you can make mistakes, realize and rectify them by painting over them. However not with watercolor. In watercolor the colour white doesn't exist. The color white is that of the paper, and the light tones or colors are achieved by the transparency of the white of the paper. In watercolor painting, if you make a mistake, i.e. you paint darker than the tone in the model, it is very difficult (if not impossible) to correct it, for which reason:

You must always paint from less to more.

180

But, be careful! This is not an absolute rule! If you are able to do it at once, if you paint immediately with the exact color, you don't need to paint from less to more, painting on top, with a second and third coat. The value of a good watercolor is precisely that, in painting the shapes, and colors *alla prima*, or *au primer coup*, at the first attempt. Look at and study the watercolors of the great masters, and you will see that they paint shapes and colors with the first brushstroke, without insisting, without going back, without touching up (fig. 180).

Fig. 180. Edward Seago (1910-1974). *Rising sun, Venice.* Courtesy of the David & Charles editorial, London. One must have total control of watercolor paint, and color, to paint a subject like this magnificent sunrise in Venice, as Seago does: without using second coats and glazes,

181

182

However, until you reach the mastery of the great water-colorists, paint from less to more. Use successive layers, as few as possible, which allow you to arrive at the exact shape and color. I am going to do this now by painting an apple. You can see it here, in the photo in figure 181, on the opposite page. Watch how I paint it starting from the next figure.

Figure 182. First step: draw the outline of the apple including the dip and the little stalk on the upper part, with a 2B pencil. Forget the outline of the shadow that the apple projects, it isn't important.
Now paint the first coat, following the rule of less to more, with a yellow color, mixing a little ochre on the left hand side, doing a gradation so that it is deeper on the left, and lighter on the right hand side, reserving the white or shine on the upper top part.

Figure 183. Always from less to more: a second coat with carmine, deeper on the left side and the upper limit, next to the small crevice. Notice that I have reserved this hole, leaving it yellow from the first layer and look at the gradation over all the apple, going towards the right, always leaving the shiny bit white. I finished this less to more painting by painting the projected shadow with ultramarine blue and a tiny bit of burnt earth shade.

Figure 184. Do everything the same as in the previous figure, with another coat, intensifying the carmine on the upper part of the apple, there is a mark of unblended carmine, on the center left of the apple, but that will be dealt with in the next step.

Figure 185. So, painting always from less to more, I finish the apple, painting the marks or vertical lines that the fruit has, absorbing paint on the bottom part, like light reflected from the white of the paper; adding light green in the dip on top and on the right outline; I paint the small stalk and the small shadow it projects; I deepen the color in the projected shadow of the apple, with more blue and earth shade, always painting from less to more... and I sign it!

183

184

185

Glazes

According to *The Oxford Companion to Art* by **Harold Osborne**, the term *glaze* is defined as *"A transparent coat of paint applied on top of another color, or over a background, in such a way that the when the light passes through the glaze, it is reflected by the underlying surface and modified by the glaze".* Most dictionaries relate the word 'glaze' with oil painting and the works of the old masters. However, the Oxford dictionary says that glaze is also used in watercolor, and cites **Turner** saying:

"When Turner painted light and atmosphere in his pictures, he applied watercolor techniques to his oil paintings, using transparent glazes by means of fine layers of oil paint".

Glaze can be used, and indeed is used: A), as a means of intensifying a color; B), as a technique to change a color, and C), as a process to modify the chromatic tendency of a subject or picture.

In the first case (A), you apply a layer or glaze of the same color to intensify its tone (fig. 186).

In the second case (B), the glaze is of a different color and changes the underlying color (fig. 187).

A watercolor painting (C), of the *range of cold colors*, can be transformed into a water-color of the *warm range of colors* with a light and general ochre color glaze (fig. 188).

186

187

A

B

188

C

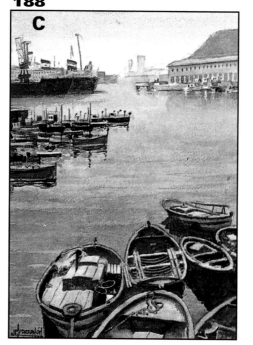

188

C

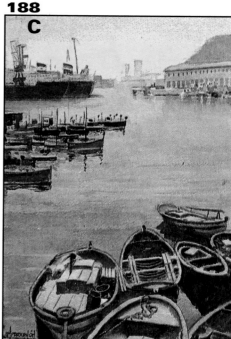

Figs. 186, 187 and 188. Different classes of glaze, to intensify a color, change a color, or transform the harmonic range of an already finished watercolor.

189

Fig. 189 and 189A, B and C. This fragment of a figure painted by Jordi Segú, shows a superimposing of tones and colors, i.e. glazes, intensifying or changing colors.

189 A

In the figure 189A, the medium deep flesh color models the figure, by means of a series of glazes applied on a light flesh color.

189 B

189 C

Figs. 189B and C. A series of blue gray glazes model the body and the dress and intensify the tone of the background in this triangular area between the arm and the body.

Tinting the Paper Before You Paint

190

Turner always painted in watercolor. When he was nine years old, he had the job of illuminating engravings. When he was sixteen, he enrolled as a student in the Royal Academy of London, and at nineteen the Royal Academy accepted and exhibited one of his watercolors in their annual exhibition. At this time **Turner** started to paint in oil, but without abandoning watercolors. Painting in an opaque medium, oil, suggested to **Turner** the idea of combining the transparency of watercolor paint with the *white bodycolor* of gouache paint. So, **Turner** invented tinting paper before painting

on it in watercolor, and achieved his blank areas with white gouache paint (fig. 190). This is something that you can do now, but reserving the white areas: draw the subject with a lineal drawing, as always; then paint the whole space of the picture, all the paper, with a very light wash of gray, or blue, or cream, or gray-green, but leaving the white areas of the subject without paint, these are the whites that **Turner** painted with *white bodycolor*.

Fig. 190. Joseph Mallord William Turner (1775-1851). *The Spring of L' Arveiron.* Tate Gallery, London. When Turner started to paint in oils, he broadened his techniques and processes of painting watercolor introducing tinting of the paper before painting, and the use of gouache white, to paint white areas and bright points.

The Technique of Painting Wet on Wet

191

Painting wet on wet has three forms or techniques: the first and most common consists of painting in an area which is still blank, wetting it first with a paintbrush and water, applying the paint when the paper is still damp, but only minimally so. The other variation, or technique, is painting on an area which has been recently painted and is therefore still wet. The third, and last, consists of wetting an area which has already been painted with water, and then painting on top.

In the adjacent figure 191, a fragment of the watercolor *The river*, my friend **Vicenç Ballestar** uses the first and most common of these techniques described in the previous paragraph, wetting the paper and applying the paint which runs and dilutes giving some first forms which are still diffused. In the next figure 192, **Ballestar** alternates painting on dry with painting wet on wet, using the technique of painting over areas which have already been painted, but are still wet, or of wetting areas which have already been painted. The final result (fig. 193), is an excellent example of the mastery of this technique on the part of the watercolorist **Ballestar**.

192

193

Fig. 191. In this fragment of the picture *The river*, the watercolorist Vicenç Ballestar shows us, at the start of the watercolor, the technique of painting wet on wet, with the diffusion of the paint and with barely determined forms.

Fig. 192. Here the forms are taking shape, thanks to some trunks and the outline of some limits painted on dry.

Fig. 193. The finished watercolor has a finish in which together with areas painted on dry, the effects of the paint applied wet on wet, are perfectly visible in the vegetation of the riverbank and in the central area of the forms reflected in the river.

The Technique of Painting Wet on Wet

Figure 194. The subject: a path that starts in the foreground, with a bank and trees on the left and a flat area on the right; a thicket in the distance topped by blue mountains. It was a cloudy day, with no sun, although in the photo you can hardly see the clouds. On the opposite page, figure 197, you can see the interpretation of the subject: without variations in the bank and the trees on the left, but raising the horizon, so with a broader view of the mountains and of the fields in the middle ground.

Figure 195. I start by wetting the sky up to the foot or base of the thicket and when it is nearly dry, I paint the two strips of grey with Prussian blue, and burnt umber with a touch of carmine. While these are still wet, I squeeze and drain the paintbrush and reabsorbing paint, I draw these light forms which appear between the two gray bands. The bottom part is still wet and with cobalt blue and a touch of English red, I paint the mountains with a gradation so that they are lighter at their base. I also paint the row of trees: permanent green darkened with English red, and I smudge the limits, opening the illuminated parts with the paintbrush.

Figure 196. I deepen the sky and the blue of the mountains. I paint the fields in the middle ground: that on the left, gray-green with English red and that on the right with carmine, yellow and ochre. With this same color, I paint the light spaces in the foreground. This is one way of reserving these spaces.

194

195

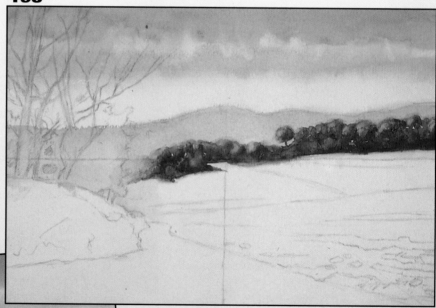

196

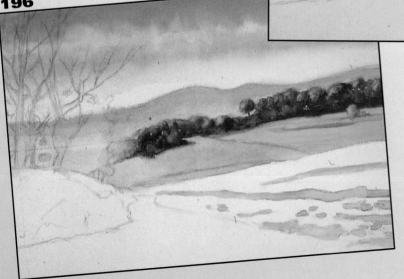

Figure 197 (on the next page). I give a first coat of paint to the path with a mixture of ochre, a little yellow, and a touch of ultramarine blue. I strengthen the green of the field in the middle ground and I paint the green of the meadow in the foreground with a general coat of paint, but keeping the reserves of the light earth color spaces. Next, with the technique of wet on wet, I draw and paint the promontory, or bank of earth and the bushy tree on the left hand side, first wetting the area which corresponds to these forms with water, so that they run and soften their edges.

On the bottom part of this bank of earth, I lift off some white lines, while the paint is still not totally dry, by scraping with the end of the paintbrush.

Figure 198. I paint the tree trunks with earth shade and black, the leaves with earth shade, getting lighter the higher up it gets. I deepen the color of the mountains in the background and the green and earth of the middle ground, and the color of the path, always from less to more. Lastly, I paint the grass and shrubs in the foreground, outlining and forming these spaces in umber.

197

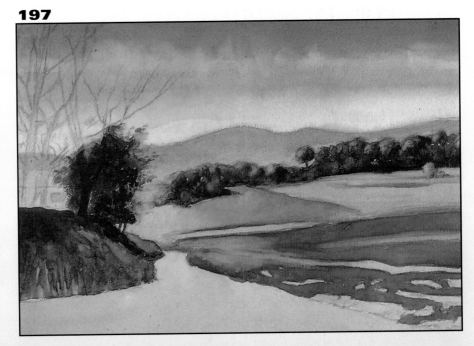

198

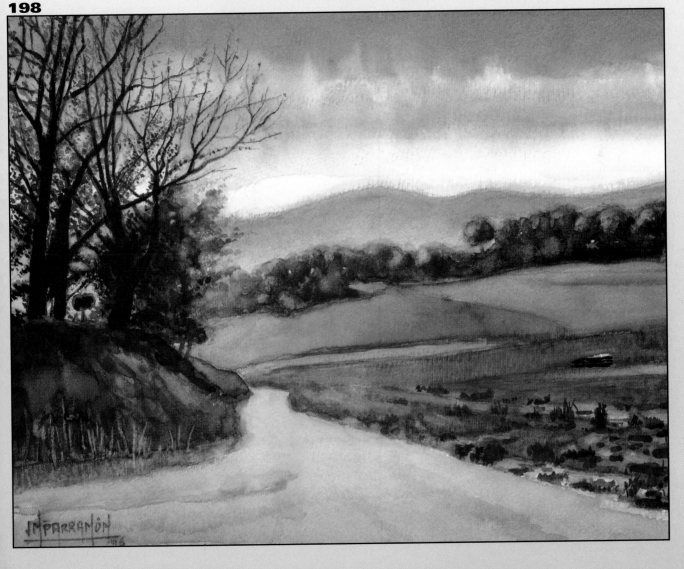

Washes, the Waiting Room of Watercolor

199

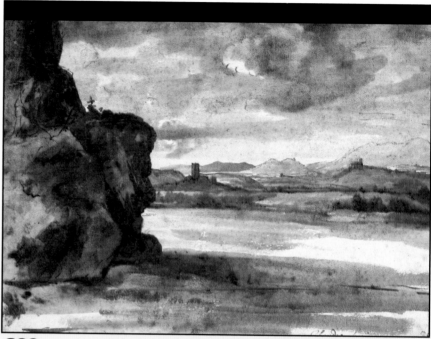

To paint with a wash is to paint with water and just one watercolor color. The masters of the XVII and XVIII centuries almost always painted their washes with the color sepia (figs. 199 to 202).

Painting a wash is the same as painting a watercolor: you paint with watercolor paint and water on white paper, with shading and gradations, always from less to more, with glazes and receiving spaces for white and light areas.

The techniques for wash painting are exactly the same as the techniques for watercolor.

This means that using wash we can learn to paint in watercolor without the problem of color, without having to worry about mixes, shades, contrasts... So yes, in effect, wash is the waiting room of watercolor, the first step towards learning how to paint in watercolor.

201

200

Fig. 199. Claudio de Lorena (1600-1682). *Tiberian landscape with rocky promontory.* Ink and sepia wash. Albertina Museum, Vienna. The painter and historian Von Sandrart, who was in Italy with Lorena, explains how he went out to paint from nature together with Poussin, Lorena and Bamboccio.

Fig. 200. Salvatore Rosa (1615-1673). *Studies of a male figure with his arm raised.* Ink and sepia wash. Museum of Art of the University of Princeton, Princeton, New Jersey. Painter, etcher, poet, actor and musician, Salvatore Rosa was the epitome of the idea of a romantic artist in the XIX century.

Fig. 201. Francesco Guardi (1712-1793) *Capricho. The inner atrium of the church.* Ink and sepia wash. The Correr Museum, Venice. More than for his pictures, Guardi is known for his *vedute* of Venice, which he painted more freely than Canaletto.

202

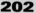

Fig. 202. Nicolas Poussin (1594-1665). *View of the countryside of Rome.* Sepia wash on graphite. The Museum of L'Ermitage, St Petersberg. According to researchers at L'Ermitage, this wash is a sketch for a picture in which Poussin represented the right-hand part of this view.

How and With What to Paint Washes

With just one color, sepia (A), Payne gray (B), colbalt blue (C)... or any other dark color, like burnt umber (below D), Prussian blue (E). You can also paint with two colors which when mixed together give black, like English red and emerald green (H)... which provides an extensive range of color, and some problems with mixes and shades, but without getting as complicated as the problem of painting with all the colors. You yourself can try it out with the practical exercises which I propose starting on the next page, and finishing with a final exercise using all the colors.

When talking about how and with what to paint washes we can also talk about themes. Any subject is valid, but try as far as possible to choose subjects where the coloring adapts to the color or two colors with which you have chosen to paint.

Fig. 203. Washes can be painted with just one color or with two colors which when mixed make black, with which you can achieve a broad range of colors and shades which will allow you to paint with real chromatic richness, as we will see in the following pages.

Fig. 204. Painting a wash with only one color will work for any subject. When you paint with two colors it is preferable to choose a subject that assimilates the mixes of the two chosen colors.

Painting a Landscape with Coffee

205

With coffee? That's right! Painting with water and coffee, as if the coffee were a watercolor paint, is something invented by the watercolorists of the XVIII century. The recipe is very simple: in a little pot or a cup, you put some instant coffee powder; add a few drops of water and wait a while, dissolving the mixture by stirring with a spoon until the powder has dissolved, forming quite a thick paste. Try painting with a paintbrush, adding more or less water to achieve a magnificent range of coffee colors, equal, or similar to the watercolor color burnt umber.

Let me say, before starting these exercises and those which follow, that it is very important that you put them into practise, in this case with this very landscape or with another that you have at hand, not so much for the sake of painting in coffee (or with two colors in the exercises that follow), but rather for the sake of painting with a wash of just one color (or two colors), having the chance to practice and learn painting in watercolor, drawing with the paintbrush, painting backgrounds and gradations, absorbing and adding paint, reducing or intensifying… without the difficulty and worry about color, i.e., not having to choose correctly, mix, contrast, harmonize, painting with and in color. Of course to make this exercice easier I have chosen a landscape whose range of colors is very appropriate for painting with coffee as the only color (fig. 205).

The watercolorist **Salvador G. Olmedo** is going to share with us the experience of painting this landscape with coffee. **Olmedo**, a professional watercolorist and winner of several prizes, is going to paint using paper from the manufacturers Guarro, thick grain, sized 30 x 26 cm and using just one single number 14 sable paintbrush. He starts by drawing the subject with a 2B pencil (fig. 206). Then he paints the sky with the paper upside down (fig. 207) so that the coffee wash accumulates in the upper part of the

206

207

Fig. 205. As you can see, this is a subject which has a warm tendency, with lots of sepia colors, which are very close to the range of tones that you can achieve by painting with coffee.

Figs. 206 and 207. The line drawing, without shading, and Olmedo painting the sky with the picture held upside down, to achieve a greater intensity in the upper part of the sky.

208

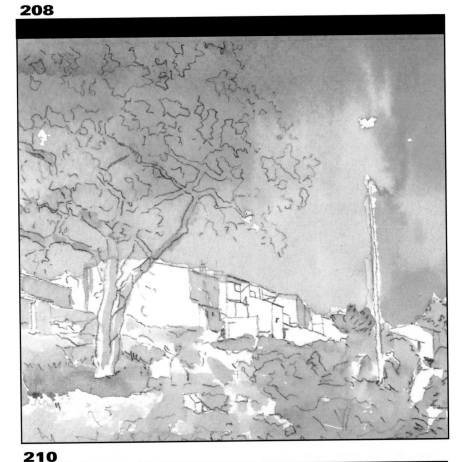

sky, with the result that the sky is a darker color at the top than at the bottom on the horizon, exactly as it should be. Next, he paints the shaded parts of the houses, reserving the white of the illuminated faces and he also paints the variations in the earth, always in a lighter tone (fig. 208). Next he makes the trunks and branches of the tree concrete because, as **Olmedo** says: "The trunks and branches determine the position and form of the groups of leaves" (fig. 209). He carries on drawing and painting the groups of leaves and then moves on to strengthening the shade on the houses and the darkest areas and forms of the earth, at which point this second phase is finished (fig. 210). **Olmedo** immediately uses a hairdryer to speed up the drying in the wettest areas. "For me this is exceptional", explains **Olmedo**, "because I almost never use a dryer. I prefer to wait for it to dry normally and, while I am waiting I have the chance to assess what I have done and what I still have to do".

209

Fig. 208. The first stage of the watercolor painted in coffee, in which Olmedo has painted some of the parts of the house which are in the shade and has applied a light coffee wash on the land or earth of the picture.
Figs. 209 and 210. Salvador G. Olmedo, with his number 14 sable brush, starts to work on the groups of leaves on the tree, the trunk and some branches. In the adjacent image (fig. 210), he also intensifies some of the shade on the house, and the irregularities in the earth.

210

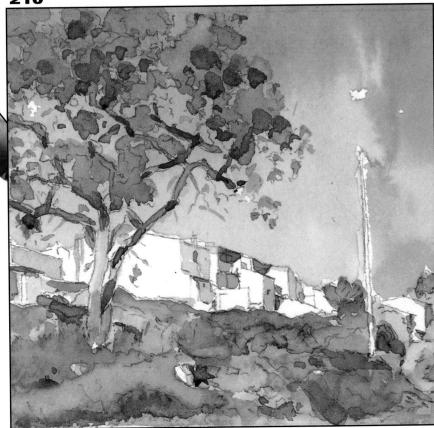

Painting a Landscape with Coffee

211

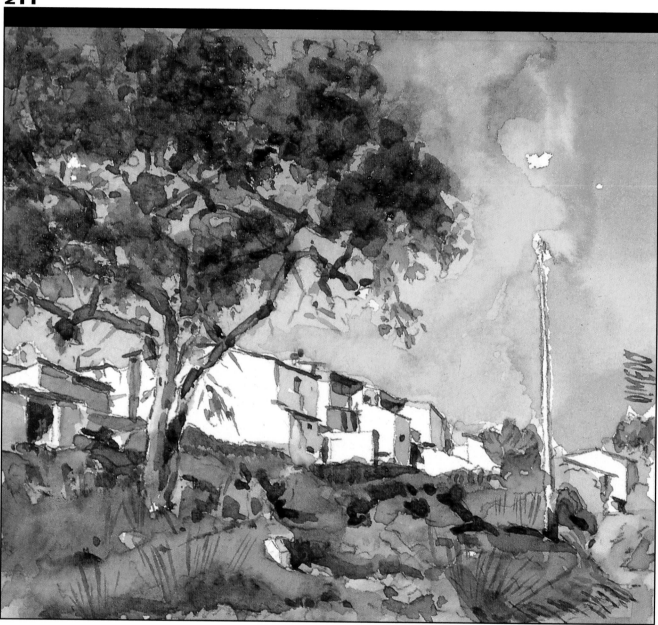

What remains to be done, here and now, is very little before this landscape painted in coffee can be said to be finished: repaint the tree, intensify the parts of the groups of leaves, the trunks, branches and twigs which are in the shade, **Olmedo** paints these, just as he does the small leaves, with the thinnest point of the number 14 sable brush. He still has to darken the shaded parts of the houses with

another coat of coffee color, always painting from less to more; tint some white or very light tones, like the path on the right, to give more relief to the white areas, like the wall in the center... and that's it. Look at the finished picture in figure 211. The artist signs it and asks:
"What do you think, Parramón?"
"I think it's great, Olmedo".

Fig. 211. Here is the final result of the watercolor painted in coffee, in which Olmedo has worked with just one number 14 sable paintbrush, including painting small forms and thin lines, showing his expertise as a professional watercolorist.

Painting a Seascape with English Red and Blue

Olmedo is now going to paint with two colors: English red, which is a slightly orangey red, but with a certain sepia tendency, i.e. it is not as strident as red-red, and Prussian blue: a very luminous blue, with a slight tendency towards emerald green. The two colors when mixed make black and, diluted with water, give a wide range of gray tones. Cold grays and black when the blue predominates, and warm when the English red is more dominant.

Without further ado, the watercolorist **Salvador G. Olmedo** contemplates and studies the model for a while (fig. 212): some fishing boats on the wharf; colors which go very well with the tones and hues that can be achieved with the two colors with which **Olmedo** is going to paint. According to **Olmedo**, he is going to do an exercise in interpretation. **Olmedo** starts his watercolor by drawing the theme, the subject of which is more of a square shape, but he draws on a piece of paper which has a vertical format, leaving a larger space between the fore, middle and back grounds (fig. 213). **Salvador G. Olmedo** then starts to paint, painting color in his way, according to the way that he sees the subject: with light colors dominating a range of muted-warm colors; with the sea light English red and the boats also predominantly light English red. The only thing that escapes this tendency is the sky, which **Olmedo** has done with a gradation in very light Prussian blue (figs. 214 and 215).

212

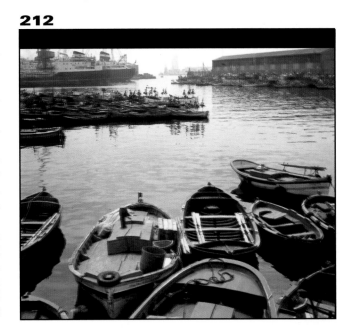

213

215

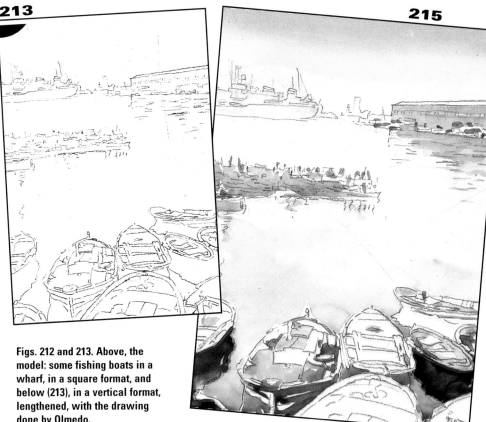

Figs. 212 and 213. Above, the model: some fishing boats in a wharf, in a square format, and below (213), in a vertical format, lengthened, with the drawing done by Olmedo.

214

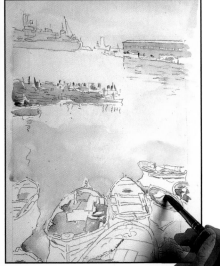

Figs. 214 and 215. Olmedo paints with a range of muted, predominantly warm, colors, including the sea which is painted with a wash of English red.

Painting a Seascape with English Red and Blue

216

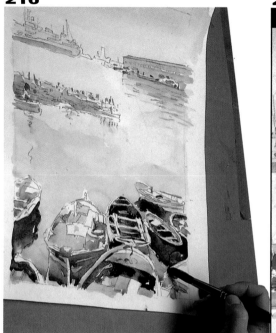

217

Salvador G. Olmedo continues painting with his way of interpreting the subject: steering clear of the blue-green tendency of the model (look and see this tendency on the previous page), and painting instead with dull, muted colors, with grays and warm blacks, alternating these with light shades of English red and light, very light blue, like the blue of the sky, of the top boat on the right hand side and in the biggest boat just left of center. He continues with the idea of light English red for the color of the sea (figs. 216 and 217). Now he paints the undefined group of boats in the middle ground (fig. 218) and, after studying and debating again for a long while, he finally decides to incorporate a light Prussian blue wash on the color of the sea, but still letting the English red "breathe", as **Olmedo** says, to harmonize with the chromatic group of the boats in the foreground.

To sum up: an excellent watercolor, in which what stands out, as much or even more than the composition and interpretation, is the excellent drawing, showing a spontaneity of style (fig. 219, on the opposite page).

Well done, Salvador.

218

Figs. 216 to 218. Olmedo continues with his own personal interpretation, in which the sky is blue but the boats and the sea are still English red.

Fig. 219 (opposite page). In the end Olmedo decides to add a wash of Prussian blue to the sea in the foreground, finishing this watercolor, in which the watercolorist Olmedo's capacity for structuring and drawing like a real master, is what really stands out.

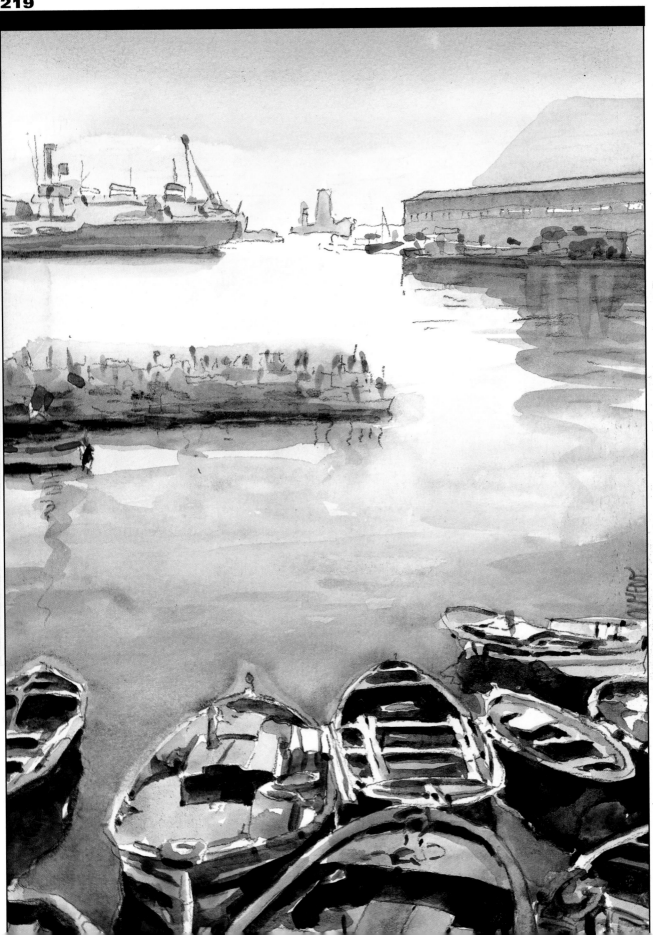

Painting a Rosebush with Green and Carmine

You are going to paint the three roses on the bush that you can see in the photograph at the foot of this page (fig. 222). However, to make things easier, the final result of this exercise, figure 232 on page 87, can also serve as a model. I say "you are going to paint", because I assume that you are practising and learning with the series of exercises which come in this book (including the one about grays and gradations, the one about glazes, the one about painting in coffee, and so on painting a seascape with only two colors and so on). I must repeat again and again that it is essential that you work, draw and paint. It's also fun, isn't it ?

You are going to do this picture as well with only two colors: Hooker green and dark madder carmine which you can see in the adjacent figures numbers 220 and 221.

Figs. 220 and 221. Hooker green and madder carmine, when mixed in equal proportions, produce a deep black, and mixed in unequal proportions, with more or less water, give a wide range of colors, some of which you can see in this image (fig. 221).

Fig. 222 (below). Here is the subject that we are going to paint: a rose bush with three roses, in a garden, with a background of dark cypresses.

220

221

222

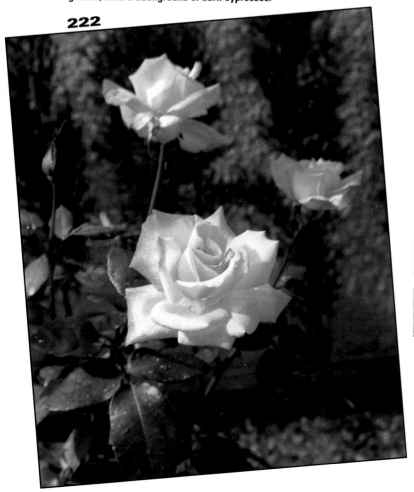

223

224

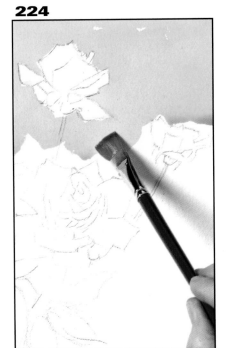

225

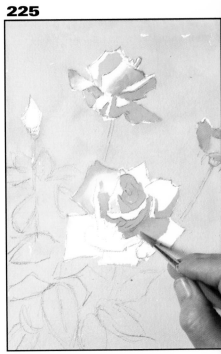

You are also playing with an advantage thanks to the addition of dark cadmium yellow, with which we have previously tinted the paper, reserving white areas of the roses, and modelling their shapes.

Let's start by looking at the wide range of tones and colors that can be achieved with the two colors we have already mentioned (fig. 221). Mixing the two colors gives an absolute black and a mix with more or less carmine, or more or less green, producing a wide variety of colors and tones, influenced by one color or the other, with hues that allow you to produce, with just two colors, and the help of the yellow, all the colors that there are in the subject.

So, let's move on to drawing the subject and tinting the paper with a dark cadmium yellow. I do it with a light color wash, drawing and painting the roses afterwards with the same yellow, but applied in its maximum intensity. It is important at this point to reserve the white parts, painting the gradations that give the roses form.

226

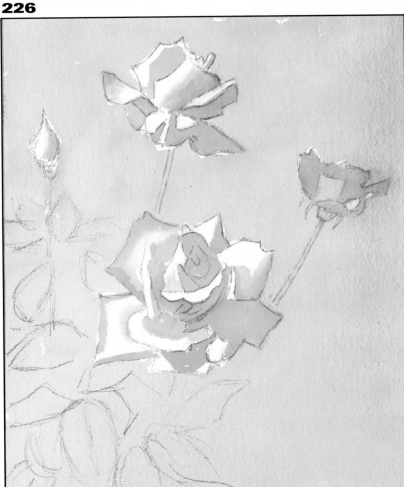

Figs. 223 to 226. As well as drawing the subject with a 2B lead pencil, on this occasion I am going to tint the paper with dark cadmium yellow, first with a general wash of light yellow, reserving the shapes of the roses (figs. 223 and 224), so that later I can paint the roses with all the intensity of dark cadmium yellow (figs. 225 and 226), then, by adding the color carmine, I can obtain the general color of the roses.

227

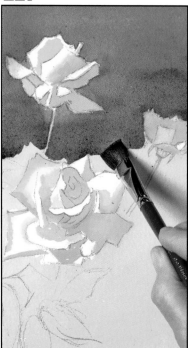

228

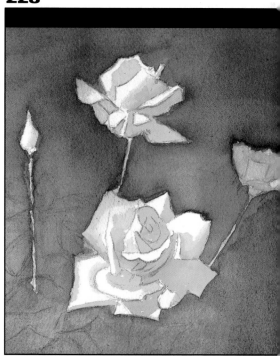

Once the light yellow background wash is finished, and the drawing of the roses, which are painted in the same, but deeper yellow (fig. 226, previous page), I add to this background a wash of hooker green mixed with a little carmine (figs. 227 and 228).

And now I start the definitive background on which to paint the red and carmine roses. This background is made up of small garden cypresses, which appear indistinctly, as diffused marks behind the roses Notice that to do these blurred, dark green marks (hooker green and a little carmine), I first wet the area (fig. 229) and then I dilute and gradate the lighter part, giving the marks a shape reminiscent of that of the cypress.

Next I paint the leaves of the bush, first, reserving their forms with the dark background color, and then painting the leaves with hooker green. I model the roses last, painting the shapes and tones of the petals (fig. 230).

On the next page you can see the final result (fig.232), with the addition of a few leaves (the leaf in the vertical position next to the bud on the left, for example), wetting the dark color and sucking up paint with the squeezed out paint brush and intensifying the general tones and color of the roses.

229

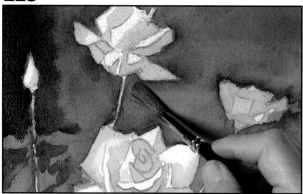

230

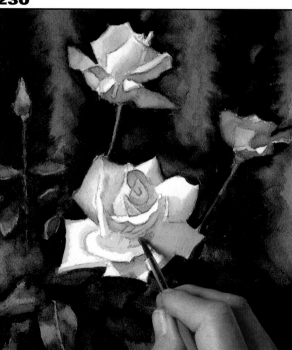

231

Figs. 227 and 228. I paint the light green background, with a general wash of Hooker green, mixed with a little madder carmine, reserving the shapes of the roses.

Fig. 229. To do the dark green marks of the cypresses, you need to wet the background and then, while it is still wet, apply a dark green color (a mixture of green and carmine), diluting it and making the imprecise shapes of the cypresses.

Figs. 230 and 232. I paint the leaves of the bush and start to do the colors and shapes of the petals, with touches of carmine, sometimes more, sometimes less intense, which, with the help of the yellow I painted previously, create the color of the roses. I add and define better the shapes of a few leaves... and I say the picture is finished.

232

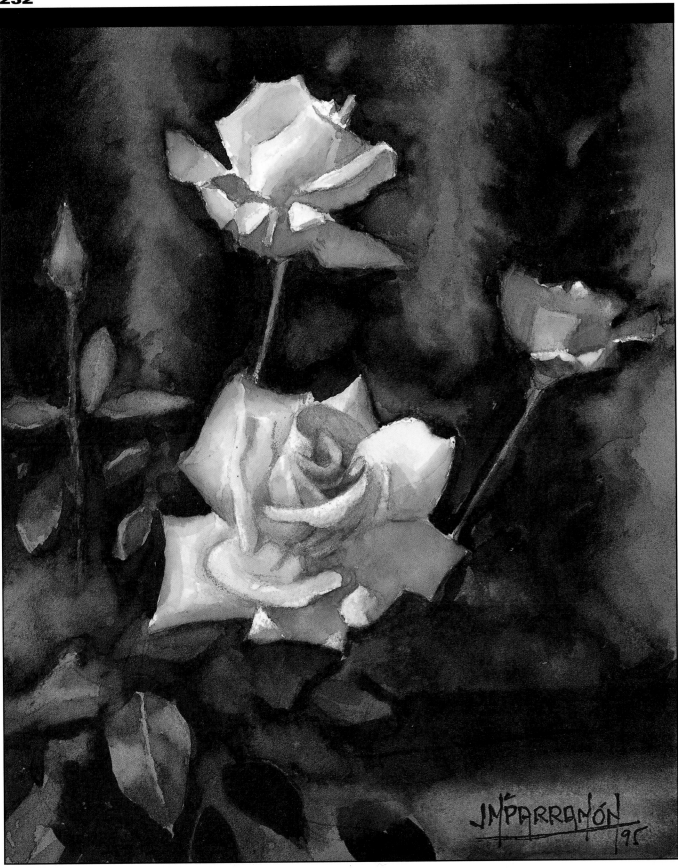

Painting a Urban Landscape with Three Colors

I am going to now paint the well known Parisian church **Saint-Germain-des-Prés** (fig. 233), with three colors: Indian red and ultra-marine blue as the basics, and raw sienna as an auxiliary color applied at some points, especially on the end walls and in the trees on the right. I will paint on Montval Paper, made by Canson, which is medium grained, sized 285 x 255, using a number 12 sable paintbrush and a number 6 synthetic brush.

The painter **Maurice Utrillo** (1883-1955), painted most of his urban landscapes from postcard sized photographs. It is not a sacrilege. The celebrated **Claude Monet** (1840-1926), when asked by his dealer Durand-Ruel if he always painted from life, answered: *"Whether my cathedrals and other paintings are done from life or not has no importance"*. I tell these stories because I have painted here from a post-card sized photograph, the one in figure no. 233, from which I did the drawing that you can see in the adjacent figure 234. Take note and don't hesitate to do the same if the situation arises. As **Monet** said: *"The result is what counts"*.

233

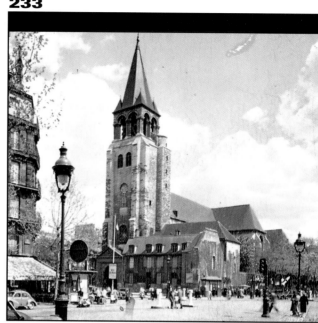

I start the painting with the blue of the sky, which I paint with a mixture of ultramarine blue and Indian red, with lots of water. I reserve the white of the clouds. I go straight on to paint, with a general coat, the light color of the tower, the walls of the buildings and the house on the left. This color comes from a mixture of Indian red and a little raw Sienna (fig. 235).

234

235

237

236

Fig. 233. The model: the popular Parisian church of Saint-Germain-des-Prés.

Figs. 234 and 235. The drawing and the first colors, blue in the sky, gray in the clouds and a wash of raw Sienna mixed with Indian red for the color of the church tower and the houses.

238

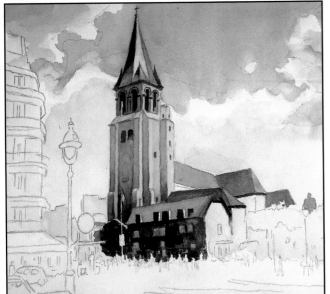

239

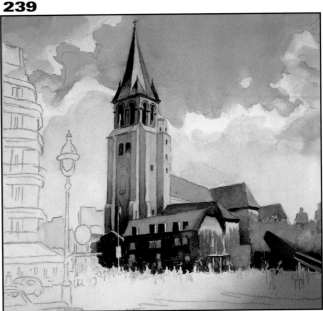

240

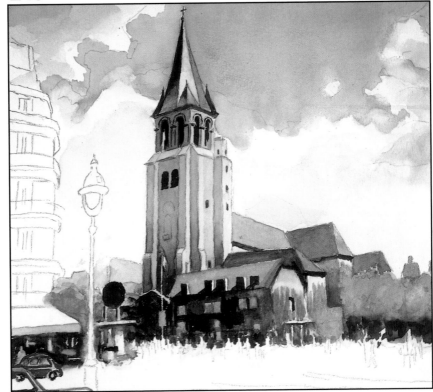

Next I paint the cupola of the church: ultra marine blue and a little Indian red, with more or less water, depending on the tone of each facet (fig. 236). Up until now I have painted with a number 12 sable brush, but now, to paint the shadows on the tower —ultramarine and more Indian red— I am going to use a number 6 synthetic brush (fig. 237).

I paint the roofs and the building in the center with reserves, on this building I also paint the pole and the French flag in blue, white and red, and the skylights and windows, as well as the white area where I will later paint the figures (fig. 238). In the following images 239 and 240 I have painted and practically finished the right and left-hand side; on the right painting the walls and the trees in the background, where, always with a number 12 paintbrush, I have added the raw Sienna shadow, which mixed with the ultramarine gives an appropriate green. You can see the final result of this stage in the adjacent figure 240.

Figs. 236 and 237 (opposite page). The cupola of the church and the colors of the tower. These are applied with a number 6 synthetic paintbrush.

Fig. 238 (above). The roofs of the buildings attached to the church, including the nearest front wall which is totally in the shade.

Figs. 239 and 240. These two images show the painting of the forms and colors on the right hand side of the tower, the walls and trees with raw Sienna and Prussian blue, to obtain this green which has an ochre tendency, and on the left-hand side this diversity of forms and colors, as well as the car in the foreground and the little red car, leaving spaces or blanks to later paint the people.

Painting a Urban Landscape with Three Colors

241

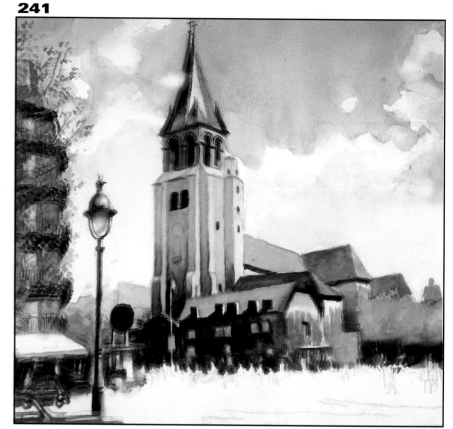

In the previous stage, I left the figures and the ground, the block of flats on the left (you can see them in the adjacent figure 241) to be done. Well, this is the process which follows. First, I paint the leaves and little branches of the tree on the left with raw Sienna and a little ultramarine blue. I already had the drawing of the small spaces which I had to reserve when I painted the walls, the doors, the railings and the balconies of the block. Later it was a question of following what was dictated by the subject, painting and filling in the spaces between the leaves, with corresponding colors, until I reached the result that you can see in fig. 241 and in the finished watercolor on the opposite page.

Going back to figure 241 on this page, notice the white mark on the left hand side of the cupola of the church. This is the white of a small cloud, which I lifted off the blue sky, when it was completely dry, by wetting this point, waiting for the water to soften the paint and then absorbing the blue color by applying the completely squeezed out synthetic paintbrush, doing this of course took away some of the color from the church cupola, so I restored this (fig. 242). Notice that I apply this same technique of absorbing color to lift off areas at the edges of the clouds on this left hand side.

Lastly, look at the following figure 243, and the finished watercolor on the opposite page, at how I painted the figures in the landscape: with the heads always Indian red, mixed with raw Sienna, the clothes different colors and the position of the figures, frontal, nothing more.

The lamp posts, the traffic light, a few last minute retouches and I declare this watercolor of *L'Eglise de Saint-Germain-des-Prés*, finished (fig. 244).

242

Fig. 241. Here is the resolution of the housing block that leans in from the left, along with the complex forms of the leaves and branches of a tree that appears on the same side. I started off by painting over the background in light salmon, drawing leaves either randomly or in small groups, so as to determine the areas that i would need to reserve for darkening the color of the walls of the house, the rallings and the shadows of the balconies.

243

244

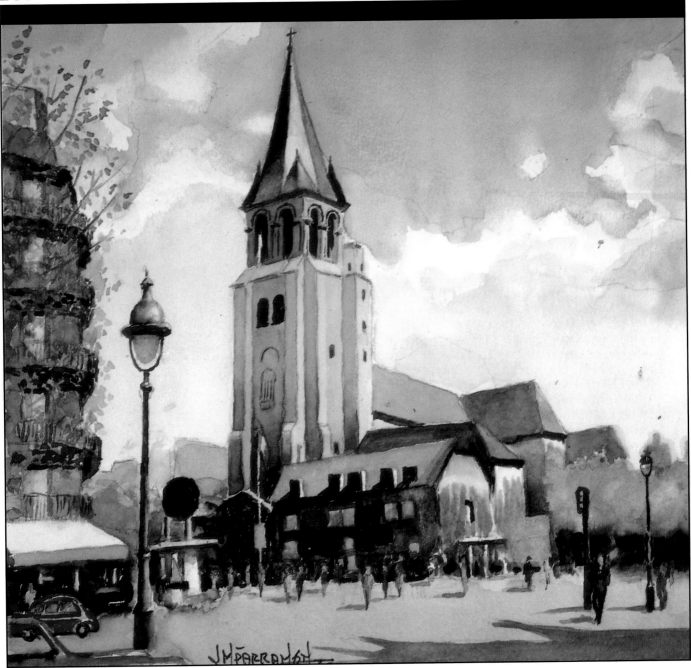

Fig. 242 (opposite page). Look here at the retouched area on the left hand side of the cupola of the church, after the technical exercise of lifting off a small white cloud on the blue sky, as you can see in the previous figure.

Fig. 243 (opposite page). Detail of the figures, painted in small blanks and gaps left deliberately.

Fig. 244. The finished watercolor with the final addition of the street lights, the traffic light and some last minute retouches.

Still Life with All Colors

Yes sir or madam; I now dare to propose painting a still life using all the colors.

You can see the model in the adjacent figure 245, which I myself set up and photographed in the studio, it is back lit. However, I am going to paint it with a few changes, starting with inclining the edge of the table and tablecloth and imagining a large window as the background, from which you can see a woodland landscape. I am going to paint with lighter colors in a colorist style and I'm going to change the shape of the glass and the color of the wine, rosé instead of white. In an attempt to sum up this interpretation, I have painted a sketch of 20 x 15 cm (fig. 246), then after looking at it I made the following corrections to the sketch: I changed the color of the table cloth by adding a light ochre colored glaze to contrast and make the light of the backlighting stand out on the fruit, the jar of grapes, etc.; I painted the panelling or strip light ochre, at the edge of the tablecloth, to emphasize the light reflected on the fruit stand (fig. 247). Finally, looking at this sketch, I saw that the shadows were incorrectly drawn, as the photo was done with artificial light and the direction of the shadows was radial, but with natural light the shadows have to go in a parallel direction.

From what we have seen and said, it seems obvious that to study and interpret the model is essential and the best way to do this is with a sketch of your interpretation of the model done beforehand. **Maurice Denis** (1870-1943), the famous Fauve painter, had, among others, a pupil called **Helmut Ruheman** who, speaking of **Denis**, said: *"I was in Paris for two years, working with Maurice Denis. I will never forget the excellent advice he gave me one day: before starting a picture, draw and paint a rapid sketch, small sized, of the composition and the color scheme and don't consider giving up this first, fresh idea for anything in the world".*

It is well worth taking **Denis'** advice.

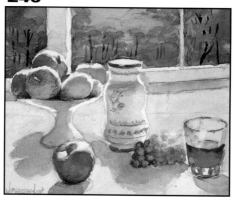

246

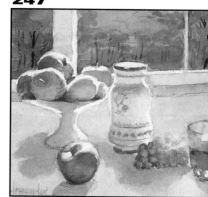

247

248

Fig. 245. The model which I composed and photographed in my studio, backlit with a flash light.

Figs. 246 and 247. Previous sketches with changes to the model: inclining the back edge of the table and incorporating a background composed of a wide window through which a wooded landscape can be seen. I have also added an ochre glaze (fig. 247).

Fig. 248. The drawing, done with a 2B lead pencil, with the paper divided with a cross to facilitate the calculations of the dimensions and proportions.

249

Remembering these changes I drew the model, starting with the cross which helps us to calculate the dimensions and proportions. When the drawing (fig. 248), was done, I painted the background forest, seen through the windows. Oh, but I didn't say that when I painted the forest background in the sketch, I was lent a hand by a photo from my files which was perfect for the job: a medley of greens, with three layers of paint, from less to more, drawing and painting without full definition to give the impression of distance (figs. 249 and 250). I also didn't say that before starting to paint I erased the cross. After painting the background forest, I painted the light ultramarine blue of the window cross pieces, the wrinkles in the tablecloth and the cloth in general, paying special attention to the shadow cast by the jam jar, done with gradations with a number 12 sable paintbrush (fig. 251). And so now WE paint the fruit stand and the fruit (I say "WE", because I am supposing that you are painting too). Well, we paint the fruit stand with blue and a tiny touch of carmine and we paint the fruit with living, gradated colors, using the wonderful number 12 paintbrush (fig. 252) and with less shadow than in the model (fig. 253). This is already how it will look in the definitive picture.

250

Figs. 249, 250 and 251. The photo from my files of a woodland landscape, painted as a background for the still life, as a view through the window (fig. 250) and in the next figure (251), the first touches of blue: in the window jams, the tablecloth and the ceramic jar.

Figs. 252 and 253. I paint the fruit with bright colors, almost without shading, in the way they will look in the finished picture. I also rub out nearly all my pencil lines so as to be able to paint with greater freedom.

251

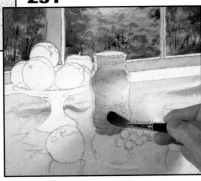

253

252

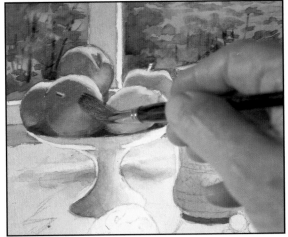

Still Life with All Colors

254

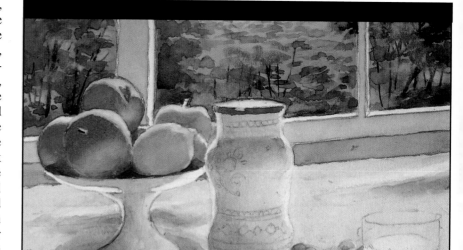

Now it is time to paint the shadows, the apple and the grapes. First, the apple: carmine with a bit of ultramarine blue in the dip on the top part and, with gradations here and there, drawing and painting at the same time, because, if you look, in the last figure on the previous page, we have erased nearly all the pencil lines so that we can paint more freely. This is how the apple turned out (fig. 255). Look in the previous figure 254 at how the shadows are painted in a parallel direction, because they are produced by natural light, and look at the finish of the apple and grapes, which, together with the glass, you can see in more detail in figure 256.

Finally, on the opposite page (fig. 257), we have the finished watercolor. I have followed **Denis'** advice; I have stuck to my original sketch, painting with the same colorist style, forgetting the model with its more dramatic lights and shadows. I have reiterated the idea of applying a light ochre glaze on top of the bluish wash of the tablecloth, to make the lights from the backlighting on the jar, fruit stand and the grapes stand out more. Lastly, I have painted the design on the ceramic jar (fig. 258) with the fine point of the number 12 paintbrush.

We have finished this watercolor and this book. Now, on to the next one, where I will have the pleasure of greeting you again and explaining with texts and images and in great detail, the techniques and tricks of watercolor painting and the theory behind painting in watercolor.

Goodbye for now and happy watercolors!

255

Figs. 254, 255 and 256. I start here, painting the vertical shadows in accordance with the parallel direction of the natural light. Next I paint the apple in general with abundant carmine and mixed with a little ultramarine blue to darken the dip in the top of the fruit (fig.255). Let me just say in passing that carmine is a complicated color with which to paint a uniform background, but it is very easy to gradate. Finally I painted the grapes and the glass (fig. 256), changing the shape of the glass and the color of the wine, which, to give the picture more color, will be rosé instead of white.

256

257

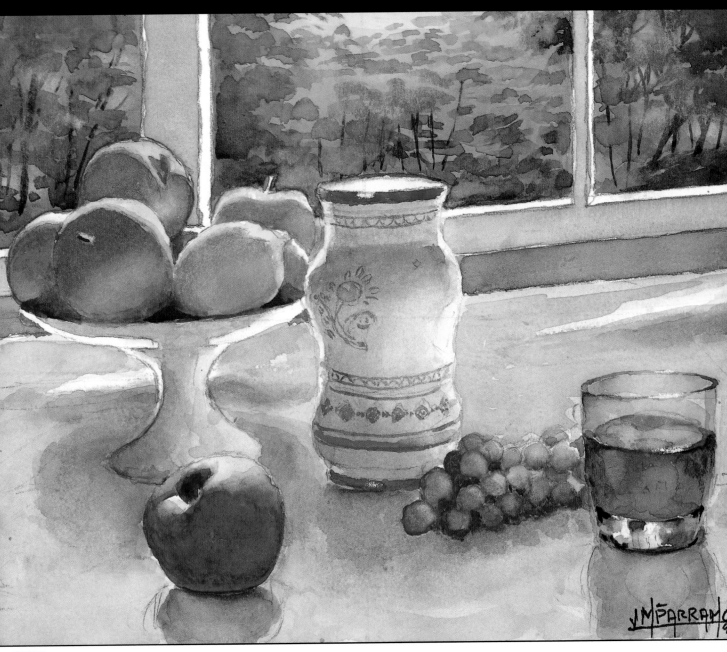

258

Figs. 257 and 258. Below, in figure 258, drawing and painting the decoration of the ceramic jar with ultramarine blue, using a number 12 sable paintbrush. While painting this still life, I have mentioned this paintbrush several times because I want to emphasize the fact that although I am painting with only one paintbrush, and a thick paintbrush at that, as it is made from sable fur, it forms a perfect point, which allows you to draw small shapes and thin lines. Take note and bear this in mind.

With regard to the finished watercolor (fig. 257), I don't believe it is necessary to add any more to what I have said in the previous pages and particularly the last paragraph of the opposite page.

Acknowledgements

The author of this book acknowledges the collaboration of the following societies, firms and individuals in the edition of this first book of *Practical Course in Watercolors*.

The Catalonian Watercolorist Association, for their kindness in allowing the publication of several of their watercolors in this *Practical Course in Watercolor Painting*, especially the president of the aforementioned association, José Martínez Lozano, for the watercolor *A Symphony in Grays*, reproduced on pages 2 and 3 of this first book. The David & Charles editorial, for their kind permission to publish the watercolors by Edward Seago and Traver Chamberlain on pages 14 and 15 of this book; José Gaspar Romero for allowing several watercolors to be published on the covers and on the pages of this *Practical Course in Watercolor Painting*. Iván Tubau for his collaboration with the texts for this first book. Salvador G. Olmedo for the painting of a watercolor painted with coffee and a watercolor with two colors of a seascape, both in the last pages of this book. Jorge Segú for the drawing and painting of several illustrations; Paco Vila Massip for his reproductions of pictures and photographs of material; Manel Ubeda from the firm Novasis for his help in the editing and production of the photomechanics and photocomposition of this book. Special acknowledgement goes to D. Vicenç Piera of the firm Piera, for his advice and guidance about materials and tools for painting and drawing, and for allowing materials and utensils to be photographed.